NORTH LIGHT BOOKS
CINCINNATI, OHIO
www.createmixedmedia.com

wabi-sabi
PAINTING with
COLD WAX

Adding Body, Texture And Transparency To Your Art

serena barton

contents

What You'll Need

SURFACES
Arches oil paper
wood panel, flat or cradled

PAINTS
acrylic paints
Ceracolors paints
powdered oil pigments
tube oil paints

MEDIUMS/SOLVENTS
acrylic gesso
Citra Solv or Gamsol
cold wax medium
liquid oil painting medium
mineral spirits
oil ground

BRUSHES
flat wide brush
stiff bristle brush
stiff fan brush

OTHER
bubble wrap
brayer
charcoal sticks
clean sand
eyedropper or spray bottle
fine-grained sandpaper
gilders paste
graphite crayons
graphite powder
hair dryer
latex gloves
lightweight collage paper
lightweight cotton muslin
marble dust
masking tape
oil bars
oil pastels
oil pens
palette
palette knife
paper towels
pottery scraper
respirator
soft cloth
squeegee
sponge
stencils and stamps
trowel
various incising and mark-making tools
Venetian plaster
waxed paper

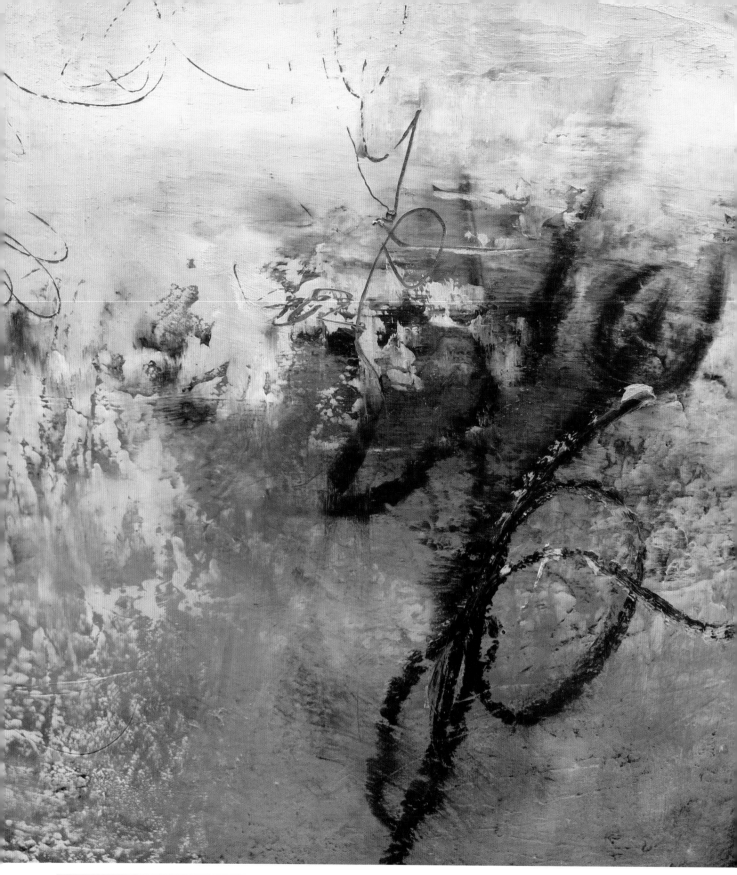

⬥ HIC JACET RECARDIS REX #3, (DETAIL)
Oil and cold wax on panel. 11" × 14" (28cm × 36cm)

introduction

My art is inspired by the Japanese concept of wabi-sabi. Wabi-sabi is a philosophy and aesthetic that honors the imperfect, the transitory, the humble and the hand-made. It honors the changes of nature, the seasons, objects and ourselves. It evokes a sense of acceptance of the transitory nature of life. Creating intuitive, wabi-sabi-inspired art with cold wax and oil paint is like taking a journey—a journey without a map.

Writing this book inspired me to play with a variety of styles, and I'll encourage you to do the same. I will show you lots of techniques for adding layers, texture and atmosphere to your work. I'll let you in on the qualities unique to oil and cold wax. Your pieces will take on lives of their own through the many layers of oil, wax and mixed media you apply, as well as the areas you choose to scrape away.

We'll explore the creative process, particularly how the process plays out when we create intuitive, abstract work. I was a professional counselor for many years. So, naturally I'm interested in personal growth and in how our minds work. When I became an artist I became fascinated by the creative process—mine and everyone else's. When I began teaching art I knew it was essential to be able to teach students in a way that fit in with their individual learning styles and creative processes.

So, why oil and cold wax? The truth is, I am obsessed with it! I find it delightful and illuminating to work with both media, adding collage papers, using pastels, oil bars and a variety of tools—many of which come from the kitchen or the junk store.

Until several years ago, I had used small amounts of cold wax with oil in paintings and to give a subtle sheen to the paint and collage pieces. When I first allowed the cold wax to come to the forefront, I was amazed at the ways my creative process was enhanced. At the time I was dealing with the serious illness of a loved one, and working with oil and wax was meditative, instructive, great fun and even combative at times. Engaging with this unusual medium gave me a full range of self-expression and allowed my pieces to serve as containers for my sorrow, joy, uncertainty, frustration and serenity.

This process of creating mirrors the personal growth process that we go through during our lives. As in life, we can add and subtract, integrating "mistakes" and unplanned development into our pieces. We move forward with the process in the faith that we will know when the piece is complete. We are free to experiment with this malleable medium, choosing and mixing colors, adding texture, smoothing and incising. Because of the long drying time, there are built-in breaks in the process of creating a piece. This has taught me to be patient and to tolerate the less than ideal stages of the piece's growth. If I dislike certain incarnations of a piece, at that point, I can step back and work on something else for a while. When I return, I have renewed energy to reshape the piece to my liking.

Sometimes the work goes more smoothly than other times. Working with oil and wax is great for learning when to add that little bit more and when to leave it alone. Sometimes struggles with a piece are what make the final product really interesting. In my wabi-sabi-inspired abstracts, the dents and dings in the paint layers, the covered-up and roughly scraped-back layers, add an essential seasoning and depth of meaning to the work that express what I feel as well as reach out to embrace the emotions of the viewer.

In my teaching life, I am continuously in awe of the courage of art-makers. You are the bravest, friendliest and most dedicated folks I've ever known. I'm honored to have twelve highly talented artists contribute to this book, sharing some of their methods and providing a window into their creative processes. I invite you to realize and honor your own creative process—experiment with the techniques and tools in this book and discover what you can create that is uniquely your own. When you enjoy the journey, the destination is eventually a wondrous place.

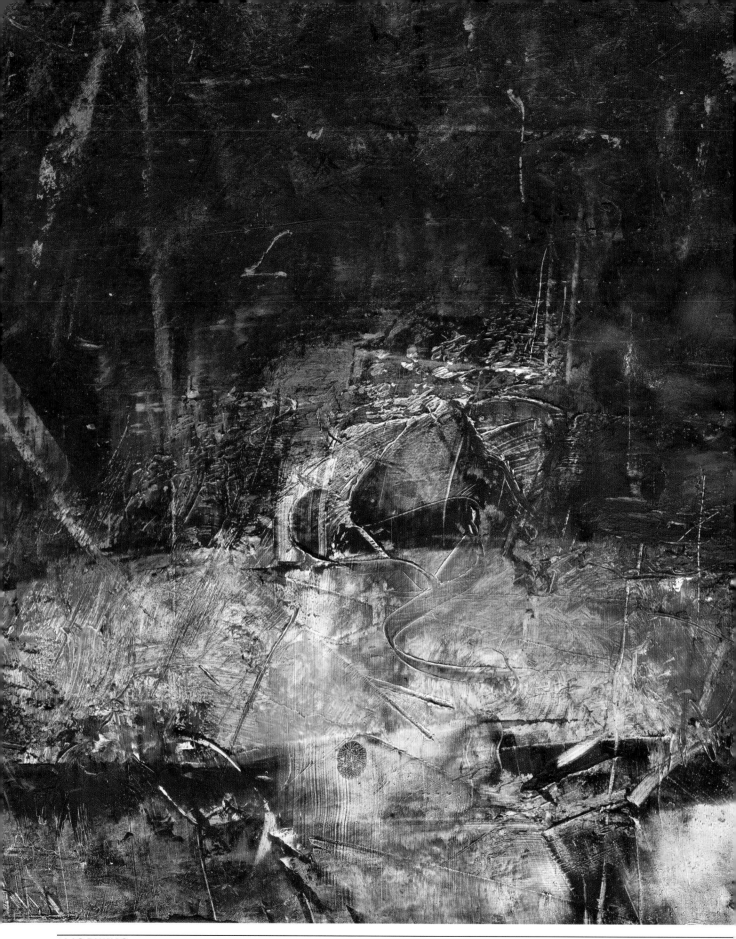

◢ LAS RUINAS
Oil and cold wax on panel. 14" × 11" (36cm × 28cm)

1 finding inspiration

While painting oil and cold wax pieces is an intuitive process, we do need to lay the foundation on which to build our piece. Even Van Gogh complained about the dread of his blank canvas staring him in the face. In this chapter, I'll share with you some ways to get your muse on board, so that you can dive into your paintings with excitement and confidence.

As a child, I looked at the paintings in my grandmother's art books over and over again. When I first began painting over twenty years ago, I studied the Old Masters, the Impressionists and the Post-Impressionists for ideas about color, brushwork, composition and style. My first pieces were inspired by the colors in Renaissance paintings as well as the colors and textures of the artwork and architecture I saw when I visited Italy. My work has changed in terms of style and form since then, but the colors of the Renaissance and the crumbling walls I saw in Italy continue to inspire me.

LOOK TO THE PAST

Umber, black, ivory, ochre and red oxide combine with incising, scraping and wiping to evoke the mystery of the past. What images of the past inspire you? Look at art from the past and see what speaks to you. This is a great way to get a starting point for color and texture. Check out some of the art excavated from Pompeii, for example. Try a piece using the greens, pinks, golds, reds and grays of the Roman muralists. Or, you could take an old slide holder and isolate one small area of a painting by one of the Old Masters. What colors and textures do you see that you'd like to borrow for your own work?

the natural world

When it comes to color and texture, the world around us is our greatest teacher. I like to take photos of unusual colors, light, textures and arrangements that I see around me. The air has a filtered soft quality where I live. I love its subtle light, and I also love the bright light in some of the places I visit.

I spend time in a lot of places that have brick reds, tans, umbers and many greens, blues and grays. Look out your window right now. What colors do you see? Even if you are looking at a gray, rainy day, see how many shades you can find. Try to translate the rain into texture or brushstrokes in your mind.

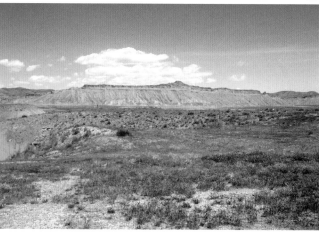

TURN INSPIRATION INTO REFERENCE

Go for a walk and look closely at the texture of leaves, rocks or shells if you are near the ocean. Zoom in on these and take some close-up reference photos. You can also stand far back from your surroundings and take in the array of color and texture that you see.

common objects, new vision

I learned how to paint when I learned how to see. Sometimes it can be a real challenge to slow down and really look at what's around us—to really see color, shape, texture, contrast and composition in ordinary things. Part of the wabi-sabi philosophy involves being in the now and seeing what is there.

I can be as scattered as anyone when I have my head full of things I need to do—calls, emails, arrangements and appointments—does it ever end? One activity I find helpful is to sit still for a little while and really look at an object near me, using my mental zoom focus to see clearly what is in front of me. I now find it's automatic for me to see parts of objects in my view as potential abstract paintings. Sometimes I squint so that I see only color and line. Other times, I don't have to do anything but look.

PHOTOS HELP YOU REMEMBER COLOR, TEXTURE AND FORM

These wabi-sabi inspired photos of an old dumpster, a vintage metal vessel, a rusty tool box and a stained table have all been used as reference in my oil and cold wax work.

haiku

Traditional Japanese haiku evoke the seasons and the emotions of the poet in three short lines. I like to think of abstract oil and cold wax pieces as visual haiku. I like to use haiku poetry as inspiration and a springboard for the work I create. My method is to choose a haiku that stimulates me to imagine experiencing the poet's vision and feeling myself. Rather than try to interpret the haiku literally with my materials, I let it roll around in my mind and heart for a while. I then begin a piece intuitively, allowing the haiku to influence me in unplanned ways.

Look for haiku in books and online. You may have favorite poetry in other forms that you can contemplate before beginning a piece. We visual people usually begin to form a sense of color and shape in our minds when we read or hear poetry or prose that moves our senses and emotions. This is a perfect place to start a piece of art.

Here is the haiku that inspired the piece below:

THE RAINS OF MAY

HERE IS A PAPER PARCEL

ENTRUSTED TO ME LONG AGO

~Sampu

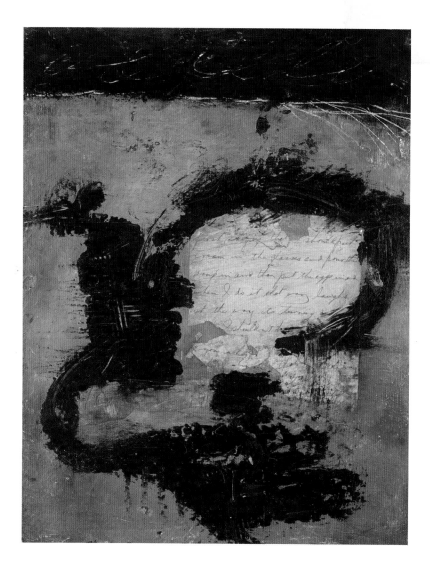

◄ ENTRUSTED
Oil and cold wax on panel.
14" × 11" (36cm × 28cm)

⬧ ELEMENTAL
Oil and cold wax on panel. 14" × 11" (36cm × 28cm)

This piece has a dynamic diagonal composition yet the soft palette evokes a feeling of calm.

from within

We tend to think of inspiration as an excited and happy emotion. We've all experienced these energetic times when we can't wait to get to work on the images and ideas in our heads. Sometimes inspiration takes a less direct form. Sometimes what inspires us comes from inside ourselves—our hopes, fears, love, worries, longings and sorrows. This can be the most powerful form of inspiration and the form we may be most reluctant to honor.

I've found that the process of working from intuition alone and the pieces that result show me exactly what's going on with me. This could take the form of feeling unable to finish a piece, or of not enjoying all of the process of creating. Sometimes I feel that a piece and I argue, struggle and shout. Sometimes I tell friends, "Yes, that piece is finished. I wrestled it to the ground and now I really like it." These are the pieces that reveal my deepest and most authentic self.

I don't mean that art can only come through suffering. That wouldn't be any fun at all! Some of my favorite pieces are born out of great joy. I just mean that sometimes we do struggle. With intuitive oil and cold wax painting, whatever is going on inside us is sure to make itself visible on the support. We need to be ready to see whatever is going on there. The layers, colors and textures of a piece contain our past and our present. They contain our history and our unique experiences of life.

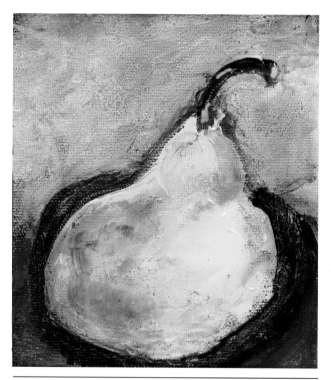

♦ GAUGUIN'S PEAR
Gouache on canvas. 4" × 4" (10cm × 10cm)

MOVE THROUGH THE STRUGGLE

Sometimes a fight with a painting can have a humorous quality. Many years ago when I was fairly new to painting, I was working on a gouache painting of a pear. It was part of my *Pears with Personality* series. I kept working on this piece, but it just wasn't interesting. I got frustrated, picked up an old towel and whacked the painting. This caused the pear to slump, suddenly giving it the oomph it needed. I now keep this method on reserve for those desperate times. Whacking the piece could save it or wreck it, but at least I feel better after I've done it—and either way—I have to move on from my inertia.

Visit createmixedmedia.com/coldwaxwabi-sabi for extras.

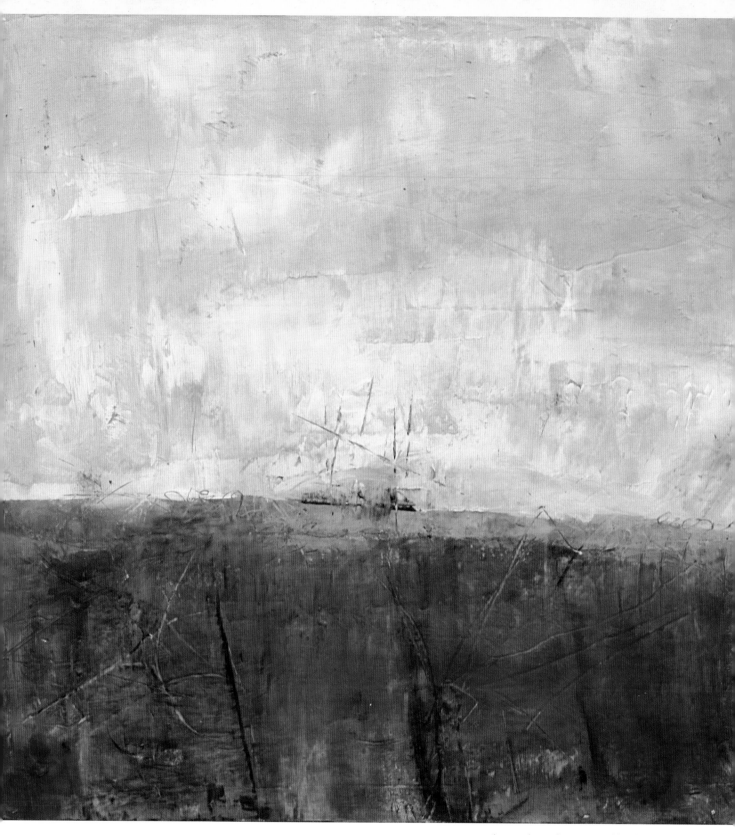

⬥ SHIPWRECK REDUX
Oil and cold wax on panel. 16" × 16" (41cm × 41cm)

I went through a stage of inadvertently painting a lot of shipwrecks. They may represent loss, but there is a strange beauty about them as well.

martha rae baker

I don't know of anyone who can capture the luminous light of New Mexico as Martha Rae Baker does. She is in love with her environment and it shows in every piece she creates. In addition to light, Martha is inspired by mesas and cliffs, crumbling walls and the passage of time.

My move to Santa Fe has influenced my work through texture and light. I am intrigued by the rich history and culture of the area and enjoy developing my paintings and collages with multiple layers. My personal vision is revealed through subtle textures that invite discovery. The process becomes a metaphor for life. All of our past experiences, one building upon the other like the layers on the canvas, weave a rich tapestry. My wish is to engage and challenge you, the viewer, to uncover the veiled mysteries.

My paintings begin with an idea that has usually germinated for quite a while. Anything and everything can spark this thought: memory of a time and place, contemporary observations, music, poetry, etc. I also begin with a color tone in mind, one that conveys the mood of the original idea. However, once I begin to paint, I don't force the issue. I begin with automatic drawing in charcoal and oil pastel, followed by spontaneous layers of color, remaining in this non-thinking state as long as possible. I allow the painting to have a life of its own, each line, brushstroke and layer informing the next.

I often work in series and stay with a theme for months, returning to it even years later. This is the case with the concept of Time, the passage of time and its effects on our natural environment. Whether depicting chronological time, marking the sequential passage of hours, days, years or seasons, or an ancient age glimpsed through excavation, the painting process of adding, subtracting and thoughtful editing is a metaphor for life's timeline. The painting, *Chronos IV*, falls under this concept of Time as part of the *Chronos Series*. In this body of work, I am thinking of chronological time and its effects on our environment through weather, erosion and human interaction. *Chronos IV* in particular refers to the earliest time, the time before Time and the mystery of Creation.

The addition of cold wax medium to oil paint allows for a rich textural surface which I enjoy. By incising lines, scraping back to reveal what lies beneath and building up layers, a "history" within the painting is created, adding to the depth and meaning of the work. My oil/cold wax paintings can have as many as six to fifteen layers of paint. I lay the paint on with an ink spatula and spread it with the straight edge of a silicone bowl scraper, scrape back with a clay-sculpting tool and incise with a porcupine quill.

On a good day, painting can be a very spiritual activity. On these somewhat rare occasions, it seems as if the painting simply "falls off of the brush," as if another hand has taken control. There is no conscious thinking, no judgment, no hesitation and at the end of the day—all the artist can do is sit back and give thanks. This is a gift we as artists are given and it is a delight. And even on the days when we are not so eager to work, the simple act of showing up in the studio can result in a successful painting. I work in the studio five days a week and consider making art to be my career.

about martha rae baker

Martha Rae Baker was born in Texas and raised in Mississippi. She received her B.A. from the University of California, Santa Barbara. She later lived in Plano, TX, where she co-owned Gallery VIII for 21 years. She studied art, design and drawing at the University of Dallas and portfolio printmaking at Collin College in Plano, as well as foreign art studies in Greece, Italy, Czech Republic, France and Russia. She relocated to Santa Fe, NM in 2006

Martha has been chosen for more than 85 solo, group and invitational exhibits throughout the U.S. and in Milan, Italy. Her paintings have been published in *Splash: The Glory of Color*, *Southwest Art Magazine*, *Watercolor Magazine*, *Pasatiempo* and *The Albuquerque Journal*.

Martha Rae Baker is represented by Karan Ruhlen Gallery in Santa Fe, NM and Brown's Fine Art in Jackson, MS.

martharaebaker.com

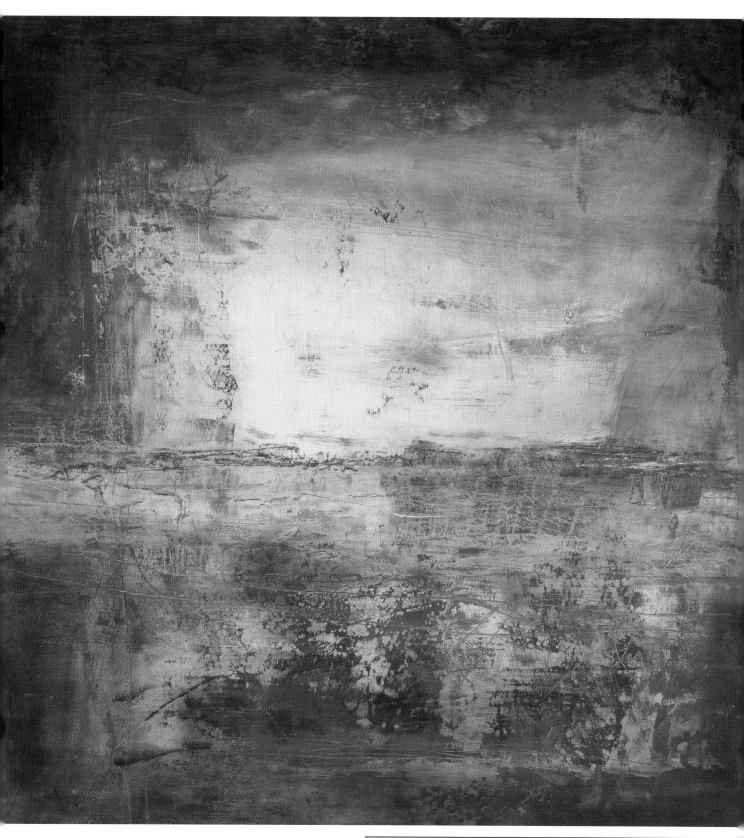

CHRONOS V
Oil and cold wax on panel. 30" × 30" (76cm × 76cm)

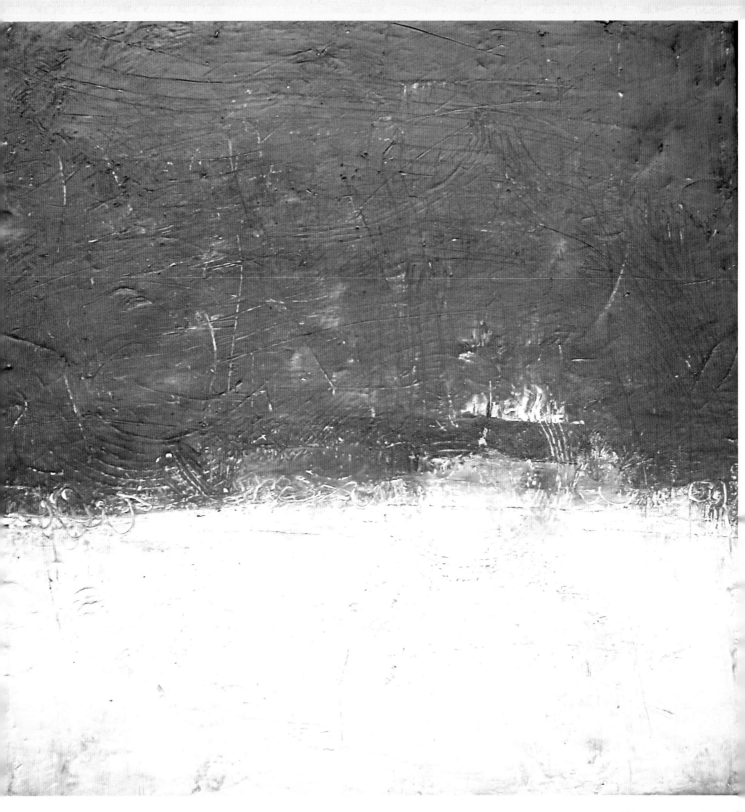

HEART LIKE A WHEEL
Oil and cold wax on panel. 16" × 16" (41cm × 41cm)

2 the creative process

t's mysterious, exciting, euphoric, annoying and often out of our control. Making peace with our creative process involves learning from it and accepting it. It means reminding ourselves over and over of what is most important—just keep going! It means doing our best to relax while we ride the roller coaster ups and downs of our creative cycle.

I've learned to take it for granted that there will be these ups and downs. Sometimes the down times come as a surprise to artists trying a new medium or a new style. As a teacher of art, it's a challenge to figure out a balance between extolling art as fun, freeing and therapeutic, while also letting students know that sometimes art-making can be hard work. We all need to develop tools to stay on and tolerate the roller coaster. The first step may be to notice the rhythm of our own creative cycle.

Which part of the creation process do you like best? I really like the beginning where anything is possible, and the end, which is both relieving and exciting. It's the middle part where things can get dicey. Sometimes my process goes something like this:

"Wow, a new beginning! Let's make some cool marks. Now let's try this, and this. Wow, I'm liking this! Well, maybe not that last bit. Take it off and try this instead." And so on until I get to, "Wow, it's almost done. This is so great. I'm going to improve just this little bit here. Oh no, I ruined it! (Wailing and gnashing of teeth.) "Okay, okay, don't panic. If you did it once you can do it again. Keep going." Repeat earlier process. Finally, "Oh, I love it! It's even better than before I ruined it. Now stop!"

Every so often a piece comes together without anguish on my part. It seems to spring to vital life all on its own. These are the times of grace and gratitude. And I have no idea how it happens. Maybe those times of grace where the work pours through us are made possible by all that we learned from the times we struggled and the pieces that didn't turn out as we'd hoped.

What I do know is that there are some stages of the creative process that most, if not all, artists share. In the following pages we'll explore some of these along with prompts to help with moving through these stages.

BLOOD, SWEAT AND TEARS

I made this piece to move through frustrations with my creative process. It has a lot of layers! It also has a lot of textures, marks and dings. I think it is a more interesting piece for all the metaphorical blood, sweat and tears that went into it. The title is from a song by Kate and Anna McGarrigle, my favorites to listen to while I paint.

accepting the stages of your piece

I've heard artists compare an unfinished artwork to a surly adolescent. I think this is quite accurate. When you are working intuitively, some things that show up on your support may not be pretty. Or even bearable. One way to deal with this is to work on a bunch of pieces at once. If your piece starts sneering at you and you don't know what to do next, move onto the next one. Drape a cloth over the recalcitrant one if you have to. Just keep going.

It helps to have a sweet baby piece to move on to so that you can again bask in the enjoyment of new beginnings. Have a couple of finished pieces around. Their seasoned wisdom, interesting dents and incisions and peaceful resolution will soothe you as you struggle through the teen years of your current piece.

We sometimes imagine that the artists we admire don't go through parenting delinquent artworks. Look at some art books that show X-rays and infrared photos of some of the Old Masters. A lot of these artists re-drew and revised, struggling to get it right. You are not alone.

TRUST YOURSELF

No matter how wise and experienced we are in the ways of life and art-making, we have moments when our whole sense of ourselves is tied up in the progress of our current piece. Past masterpieces, achievements, accolades—none of these matter when we are in a pitched battle with a stubborn artwork. All those past glories mean is that if we can't create another masterpiece, right now, we are about to be found out as an imposter!

The usual advice for this temporary madness is to just step away from the painting. I find this hard to do when I'm not happy with what's happening. It's at this point that I can tend to go on past hunger and exhaustion, getting nowhere. What I've learned is to get the piece looking a little better, even if it means covering it all over in a solid color. Then I can step away and go to the movies or out to eat. This doesn't mean I won't keep going, but I need to get away from the studio and get some perspective. I am not the current state of my current painting.

Leave the work alone long enough to get your bearings and remember what Oscar Wilde said, "Life is much too important to be taken seriously." Substitute art for life and you won't get in your own way so much.

ENCOURAGE YOURSELF

- Reward yourself for taking a break. Set a timer that will alert you to stop painting, wash the muck off your hands, and have a treat. Watch a TV show while you eat a healthy and delicious snack. Read a chapter of an absorbing book. Take a walk someplace you find interesting. Visit with a friend.

- Make a poster of your successes and compliments you've received. Stash it in a secret place and get it out when you are alone and doubting yourself. You will succeed again. A big part of success is enjoying the process of art-making. You'll find your way back.

- Notice how well you are taking care of your physical and mental health. Artistic fervor can result in missed vitamins, missed meals and missed time with friends. Not good in the long run.

- Give yourself permission to make something really ugly. I mean, *really* ugly. Get into it. Have fun with it. Notice how the world doesn't end when you do this. If the piece does turn out ugly, then you have succeeded. If it turns out well, then you have succeeded.

- Name what's going on if you are having a hard time of it in the studio. "Oh, this is that place again." Come up with a funny name for it.

- Ask a good friend to open their complaint department and let you moan about your plight for fifteen minutes. You'll feel better afterwards. You may even see the humor in it all.

- When you are having a good time with your art, write yourself an encouraging note that you can pull out when things get rough.

► **STUDY FOR BONFIRE NIGHT**
Oil and cold wax on panel. 5" × 5" (13cm × 13cm)

 Visit www.createmixedmedia.com/coldwaxwabi-sabi for extras.

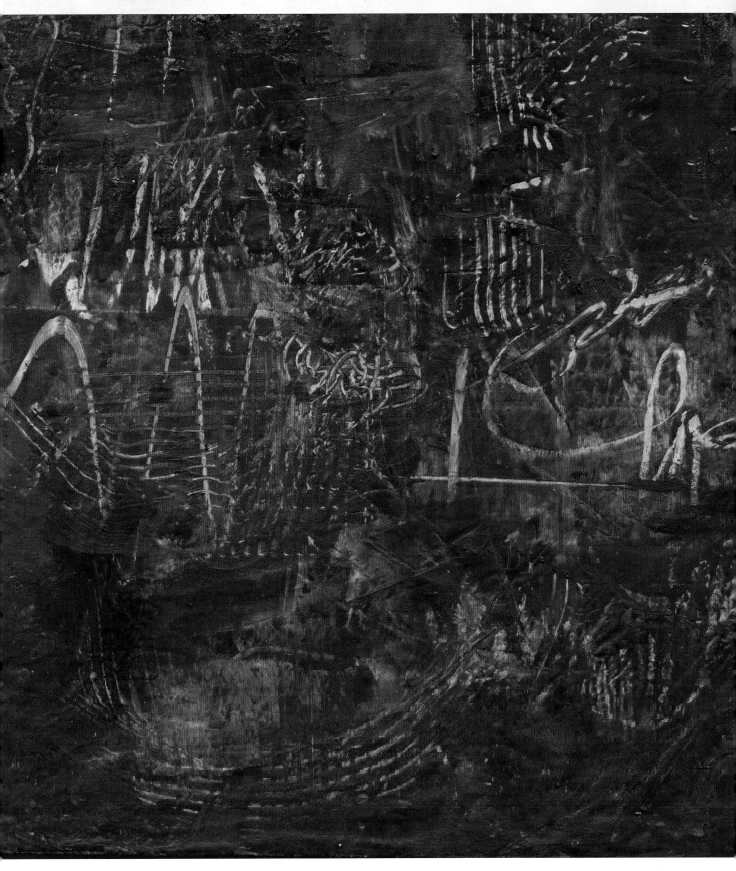

IMPROVISE!

This piece was created with improvisational abandon. I didn't care if it turned out to be awful. That freedom made me bold in my texturing and gestural marks. I think maybe it isn't too bad! Either way, this study piece inspired *Bonfire Night* (shown in Chapter 13).

imperfection and happy accidents

Some readers may recognize these terms from the subtitle of my previous book. Imperfection is wonderful. It is a tenet of the wabi-sabi aesthetic that imperfection is much more interesting than perfection. Perfection is static. It doesn't move, it's not going anywhere and it is dead boring!

Oil and cold wax work thrives on imperfection. We create surfaces, uneven lines and varied and unpredictable textures. The viewer continually finds new things to see in the pieces. An oil and wax painting is like a life—no perfection here, but a wealth of interesting detours and layers.

Sometimes a mistake is just something you don't want, and you can take it out or cover it over. Sometimes a mistake is a gift, often called a happy accident. Many times I have looked at a nearly completed piece and thought, *I don't know how that mark got there, but I really like what it does!*

It can be unnerving to let go of perfection. With perfection you know where you are going and what you want to achieve. Get out the ruler and eraser and make those lines and shapes perfect. When we embrace imperfection we embrace vulnerability. Our true selves will emerge in our art— what will that look like?

In a way I have been lucky. I am simply incapable of perfection. I make crooked lines even with a ruler. When the third grade class cut out those fancy snowflakes, mine ended up being just a mess of paper. When we cut out rows of paper dolls, my dolls weren't connected after I cut them out. This caused my teachers and me a fair amount of grief back in the conformist 1950s. Now, by a series of happy accidents, I spend much of my time helping perfectionists become imperfectionists. No perfect art exists, so we can all do our best to just to enjoy our process. But we don't have to be perfect about that either.

Along with imperfection comes the idea of asymmetry. While we strive for balance in a piece, this doesn't mean that elements should be perfectly organized and alike. In order to have life and movement in our pieces, we want to have things just a bit uneven. I remember watching my mother arrange colored cushions on our sofa. She put three cushions at one end and two at the other. This offended my young self, and I loudly maintained that there should be the same number of cushions at each end. My mother couldn't convince me otherwise. Time did that, and as I got older I was able to see how much more interesting it was to have an odd number of cushions on a sofa. This is the essence of the famous Rule of Three: uneven elements provide an interesting tension. (And it doesn't have to be three; it can any odd number.)

► FLYING NEAR THE SUN
Oil and cold wax on panel. 14" × 11" (36cm × 28cm)

TAKE RISKS!

The dark shape between the Celadon and the gold area on the left was a happy accident. The piece reminds me of the myth of Icarus who flew too close to the sun. His wax wings melted and he plummeted to Earth. I wonder about the message embedded in this ancient story. Maybe it's not dangerous to let ourselves take risks and fly when we're experimenting with our art.

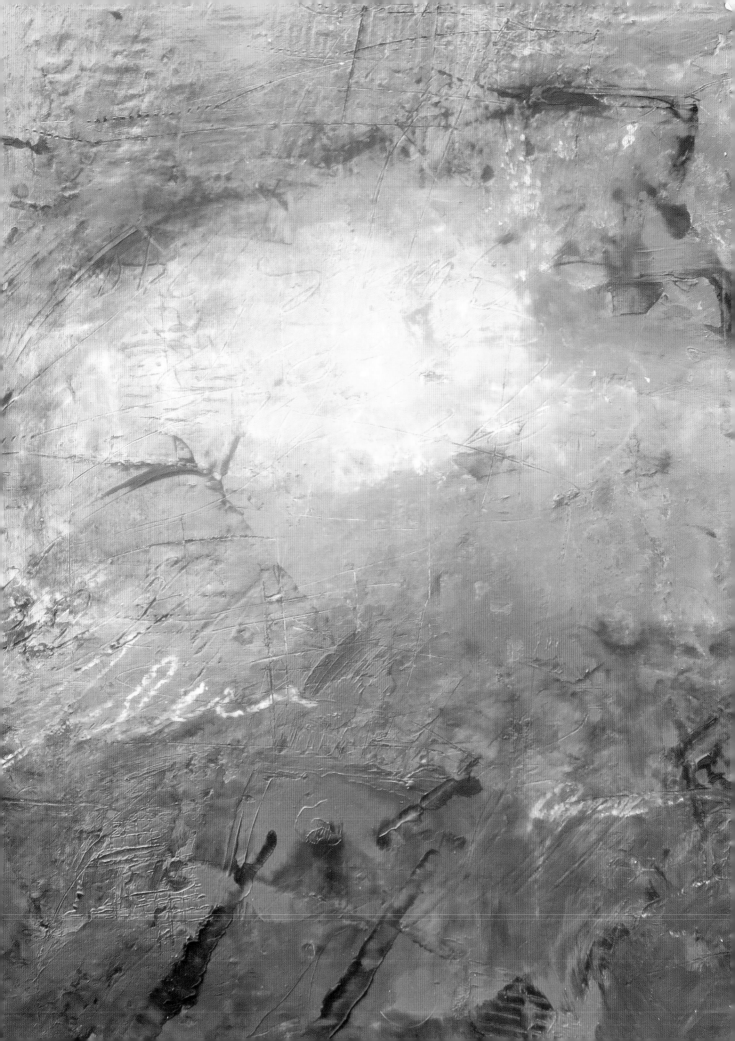

getting through blocks

This is a fascinating topic to me, as it is one that resonates with the majority of creative people. I want to share a few ideas and techniques that have helped me and my students. Notice that this section is called "Getting Through Blocks", not "Defeating Blocks" or "Making Sure You Never Have a Block Again." Big or little blocks are always going to be part of the creative process.

Let's back up and define what we mean by a block. I think a block is whatever keeps us from our artwork or at least keeps us from enjoying the process of making art. We've looked at the belief in the need for perfection, the belief that our best work was just a fluke, the belief that art should come easily. These are definitely blocks. Others can be more subtle. We've talked a bit about our fears of vulnerability. We are vulnerable when we make art, maybe especially abstract art. What if we show too much of ourselves? What if we never find an audience? What if we do? What if people don't get it or don't like it? Maybe the block is a way to avoid this risk.

No person on this earth is 100% emotionally secure all the time. So we less-than fully secure people are going to have occasional blocks based on fear and self-doubt. Another kind of block occurs when we feel out of ideas. You aren't against the idea of making art, you just can't think of a way to get started. I find this block to be an especially poignant one to have because it means that I haven't been feeding my artistic soul enough.

Okay, so now what can we do about it?

- It helps to know that the more cyclical blocks we make it through, the more we're able to reassure ourselves that we'll get through the current one.

- Counter any critical or fearful thoughts with a reminder that you will get through this block.

- Write out a conversation with your block. What does it want or need? More stimulation? More rest? Maybe it needs you to let it be because what is really happening is that you are on the verge of a breakthrough and are in transition. (Like a snake shedding its skin—not a pretty sight but a necessary stage of growth.)

- Make a 2- or 3-D representation of your block. See what comes out. Is it a sad block that needs comfort? A scary monster? You can choose to mentally comfort a block, or befriend a scary monster.

- Again, bring your humor to bear on the situation. Pretend you are your block and make monster noises, creeping around the studio.

- Re-frame the situation. Instead of saying, "I'm blocked," try using a phrase like, "I'm practicing the fine art of studio avoidance." Again, humor is your best ally in keeping things in perspective.

- Get out and see art, nature, new places, great movies and plays. Feed your eyes and heart.

- Make any marks you like on a support. Oil and cold wax are perfect for this, as there's almost no limit to the layering, covering up and revealing of old layers that you can do.

- Visual journaling has helped me and many others through the blocked times. Getting it out with words and images frees us to move on. The journal becomes a container for your angst and helps you get free of it. Visual journals are also an excellent place to put encouraging and joyful images that will inspire you when you need them.

JOURNAL PAGES

These are some journal pages I've done over the years that deal with times I've felt blocked. The blocked times are fewer, farther between and shorter these days, and I think visual journaling has helped a lot with that. These images were not created to be seen by anyone else, and I haven't tried to make them into finished works of art; they just are.

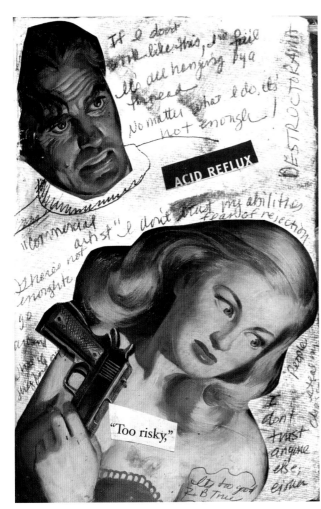

1/10/08

Diane and I had
Key Lime Pie
She cut and I picked.

improvisation

Working with oil and cold wax is all about improvisation. No scripts, just your impulses and intuitions of the moment.

I had a dream many years ago. All I remember about it was that I awoke understanding much more fully than before that life is an improvisation. We make it up as we go along. Some of it works and some doesn't. If it isn't working, we have to change course or change how we are looking at what we are doing. I had another dream around the same time, and again, I don't remember the story. I just remember thinking the story was dumb and yelling (in the dream), "Who made this stupid movie?" Then the credits rolled: Director: Serena Barton, Starring: Serena Barton, Produced by…you get the idea. I felt both sheepish and enlightened on awakening.

How scary and yet freeing it is to realize we are in charge of the movie of our life. External forces certainly impact us in ways we can't control. We are only in charge of our internal processes and of how we express these in the world. To grow as humans we have to experiment and improvise. This holds true in the studio as well.

Rembrandt did a wonderful painting called *The Artist in his Studio*. On the right side of the canvas, we see a giant easel facing away from us. On the easel is a canvas that we just know is blank. To the upper left is the artist—a short man with huge dark eyes staring fixedly at the large canvas, brush in hand. From his expression we can tell that he has no idea what to do. He seems to be almost shrinking against the wall behind him. This painting always makes me smile because I know just how that artist feels.

What the little artist needs is to improvise. Do something, anything, even scribbling on the canvas. He's the only one who can change the narrative from one of immobility to one of action.

Some improvisations you can try:

- Go to the paint store or online and buy a color you have never used. My work has tended to be made of warm colors like Burnt Sienna and Yellow Ochre. I recently discovered Portland Cool Gray, a color I never thought I'd use, as I'm so crazy about warm colors. The gray has changed my life! It's brought many an overly warm painting to life, and I'm so excited about this color that I can't wait to lay down the paint.

- Revel in the realization that you have no idea what you are doing. I don't mean that you don't have any talent or technique, but that how you will use these on a given piece remains a mystery. Try this, then that, then this. Take the mad scientist as your role model. You will eventually see what works and what doesn't and adjust your piece accordingly.

- Close your eyes and make some marks on your support. Leave the ones you like and cover the ones you don't. Or, leave them all and put on another layer when the current one is dry. Scrape back to reveal the marks you like.

- Ask yourself, "What if?" What if I mix this color with that? Wow, that looks great. How about if I add this color? Ugh. Won't do that again. Okay, what if I used this object for a tool? I like the marks it makes. Keep your what-if mind open to any and all improvisation.

◄ FULL FATHOMS FIVE
Oil and cold wax on panel. 14" × 11" (36cm × 28cm)

This piece was inspired by both the metal toolbox and metal vessel photos in Chapter 1. I borrowed some color from both photos and the roundness of the darker areas from the photo of the vessel.

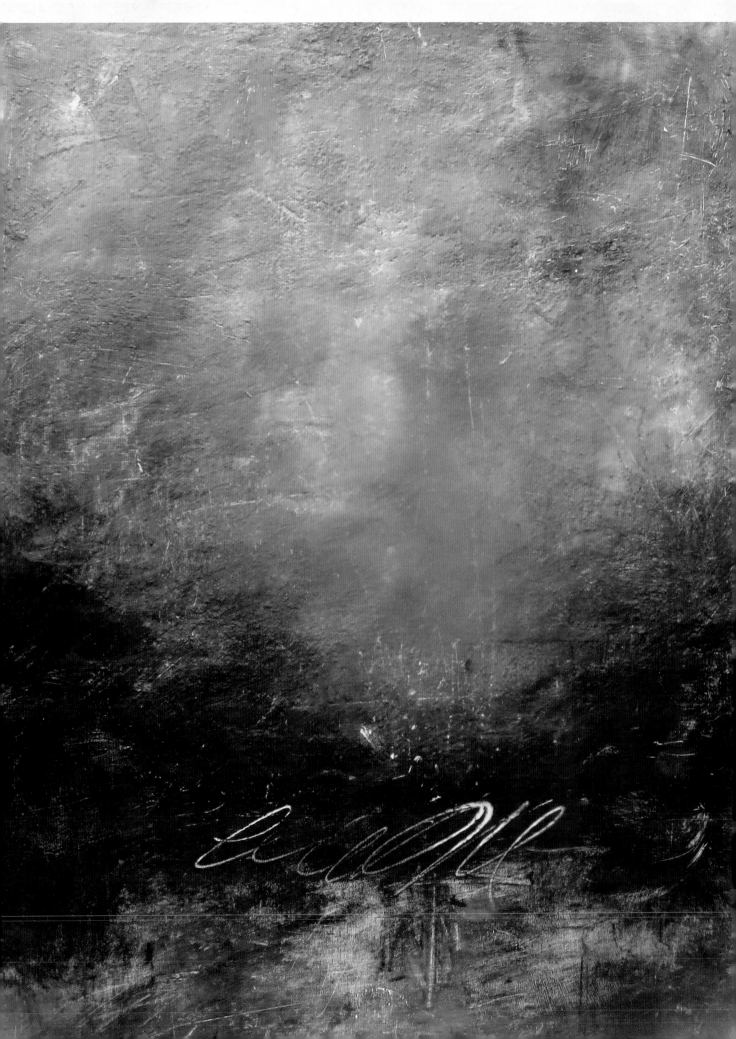

keep going

It's important, as I've said, to take breaks during a painting session, and maybe even at certain times in your life. But overall, we need to keep going at our art. Sometimes when your spirits are in the trough, it's tempting to think maybe you'll just quit. Who needs to make art, anyway? Lots of people are fine without it.

But, honestly, would you be? If you give up the times of uncertainty and discouragement you also give up the magic of the times when the art pours through you. The times when you want to weep for joy when you view your completed piece because it so beautifully expresses who you are, how you feel and what you believe.

If you quit, you'll lose the thrill of going to an art supply store and glorying in the possibilities of all that you could do with the paints, papers, pastels, inks and other supplies therein. You'd lose the sense of coming home to a place that understands you.

And what about our tribe? Now that we have the Internet, we art-makers can connect with countless others who are interested in and obsessed by the same materials and processes that we are. People who get why our studios look like something from an episode of *Hoarders*. People who know the ups and downs of the creative life. People who will provide support, thoughtful feedback, jokes and caring. People we can encourage and share with.

When I was newer to art-making, I used to fantasize about giving it all up when things weren't going well. I never do anymore. I know I'm in this for the long haul. Even when I think my current work may be sorely lacking, I know I just have to keep going. If I didn't, I wouldn't be me.

Knowing you can't quit and have to keep going is a great relief. The crummy song will be over soon and the next one will be one that has you dancing, because you kept going.

loosen up with contour drawing

Some of you have done contour drawings in the past. This involves drawing an object or person without lifting your pen or pencil from the paper until the drawing is finished. A variation involves drawing an object the same way but without looking at your paper at all. Try some contour drawings to loosen up. Notice how much life they have despite, or because of, their technical inaccuracies. See if you can bring this spirit to your next piece.

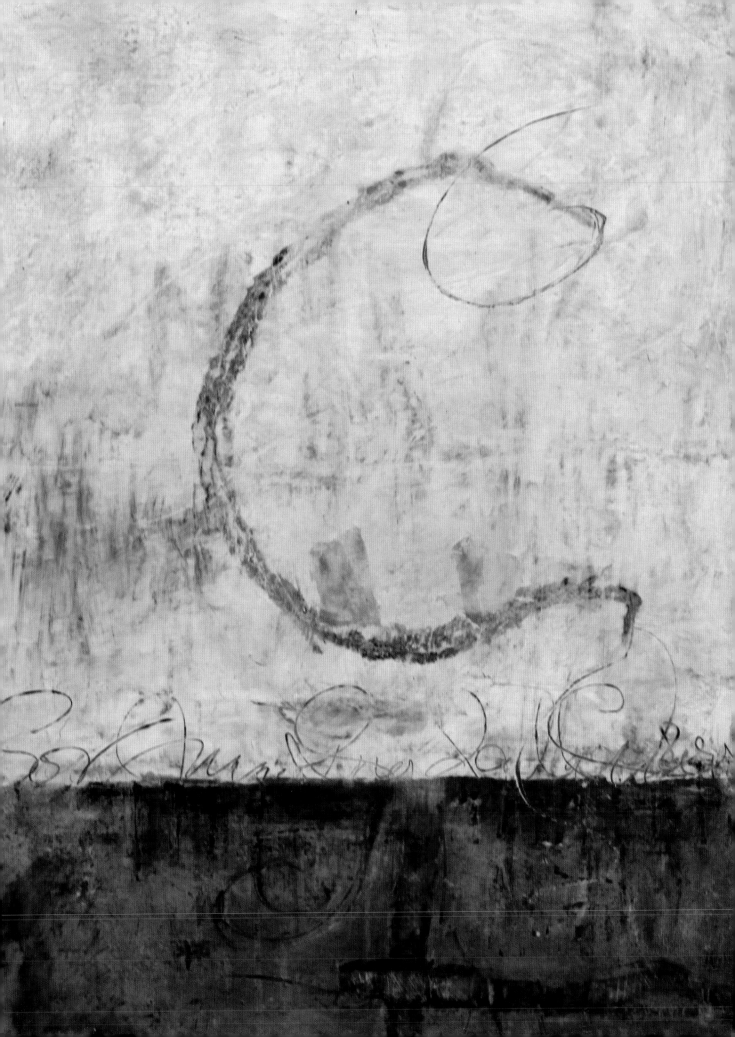

creative reconstruction

I've read a lot of books on art-making and writing. They all talk about the need to adapt our work to what it is shaping up to be, not what we thought it would be. Some use the phrase, "Kill your darlings," or even, "Kill your children." (As a mother I can't get behind the latter one, even though I know it's metaphorical.)

What these phrases mean is that sometimes (often), we have to eliminate our favorite part of the artwork we're creating in order for the whole to become cohesive. Your favorite part of your painting may just have to go for the good of the piece.

When I was a child, theater was my passion. I had lots of records of Broadway musicals and loved to sing along with them. I remember the liner notes on the back of the original cast recording of Meredith Willson's *The Music Man*. The notes described how Willson started that musical with a whole trunk full of songs he planned to use. One by one, he had to replace them with new ones as his work took shape. Finally, there was only one original song left. He tried to keep it in the musical, but it just wouldn't work. Reluctantly, he let go of the last song from the trunk. *The Music Man* was a huge success on Broadway and it became an equally successful Hollywood movie. The original songs stayed in the trunk. Don't think of those original songs as wasted, though. They are what got him started in the first place. I think our "darlings" are worth creating and honoring, even though we may have to say goodbye to them.

Before you begin deconstructing…

- Take a photo of your darlings before you take them off your piece. Maybe they'll be a valuable design for a future piece, or just look good by themselves in a collage or on a card.

- Remind yourself that excising your favorite part of the piece is a sign of a *real artist*. It means you have guts and courage. Play some inspiring music while you do it. Thank your darling for encouraging you along the way.

- Be willing to start all over if you have to. There's no shame in it. Creation and destruction are two sides of a coin, and we must learn to be comfortable with both of them.

- Wait before you destroy. Sometimes destruction isn't what's called for in a given moment. Take a break and then stare at your piece for a while. You'll know when it's time.

▸ PORTRAIT OF A LOST DARLING (DETAIL)

simplicity

Oil and cold wax pieces have so much richness in their layers, colors, incisions, marks and texture. I mentioned earlier that the middle of a piece is most challenging for me. At times I forget how lovely and translucent a simple design can be when executed in oil and wax. Sometimes I've taken a detail photo of my piece and when viewing the detail later, I thought, "That bit would have been enough by itself."

Try taking some detail photos of your pieces including current ones that are giving you trouble. See if the detail shots inspire you to simplify the composition or the number of colors you're using.

I've seen a lot of students overwork their pieces in the middle and I've done the same. Maybe a given piece is not too simple. Maybe your embryonic piece needs just a bit of accent to be finished.

Working in oil and cold wax is teaching me a great deal about simplicity. I'm learning to simplify my designs when I find myself trying too hard. I strive to simplify my process as well. It's just me and the wax, the paint and the support—let's see what happens!

→ FUTURE/PAST
Oil and cold wax on panel.
10" × 8" (25cm × 20cm)

I was going to do more to this piece.
My trusted partner told me to stop, so I
did. She was right.

james edward scherbarth

Jim Scherbarth's paintings have a magical ability to evoke emotion in me and make me glad I am alive to feel it. He is stellar at creating layers of meaning and memory while remaining completely abstract in his work. The piece opposite was inspired by Jim's travels to Ireland and reconnecting with his Celtic roots.

I draw my inspiration and ideas from nature (landscape), patina (weathered, rusted, aged surfaces) and language (words, phrases, script, calligraphy and gestural mark-making). I bring these elements together to create a sense of history and place. Memory is essential to my process as I don't work from printed images. I plumb my memories, especially those of my travels, for inspiration. Ireland has a very special place in my heart. Its beautiful landscapes are infinitely inspiring.

Sometimes I start with an idea and sometimes not. Often I just make a mark on a panel to start the process. That way I have something to react to, and the dialogue between painter and painting begins. On occasion, I work with a specific intention, word, phrase or emotion as my starting point. I try not to be too specific so as not to limit my options. I try to remain open to the unexpected or happy accidents inherent to the process of layering and color interactions. The majority of the time, I make the initial mark on the panel using whatever paint is on the palette. My approach is to build a complex surface that I then edit with the goal of achieving what I call a complex simplicity.

I use powdered pigments, marble dust and oil bars along with graphite in powdered, stick and transfer form. With my specific landscape travel-inspired paintings, I often incorporate sand that I have collected from the beaches and coastlines I've had the opportunity to visit. The white coral sand from the Mexican Caribbean and the coarser, dark sand from North County Mayo, Ireland are two of my favorites. When I run out of these, I know it's time to plan another trip.

The majority of my work is accomplished with a palette knife, a scraper, a brayer and a whisk broom. Rather than an expensive designer tool, I prefer a homemade or found tool, such as a piece of scrap mat board, a bamboo skewer or the plastic wrapping from painting panels. I will use whatever is at hand to create a texture that I like and that works for the piece.

Each piece of my art is uniquely accomplished through layers of color, line, and texture. I love the process of art-making and the creation of imagery through an increasingly spiritual conversation with myself and with the universe. Inspired by continual learning, sharing and traveling, my creative process is an intuitive process of constructing and deconstructing; of collecting, blending, erasing, blurring, mark-marking and clarifying. The process mimics the natural processes of the world: accumulation, erosion, growth and decay, recording the evidentiary marks of life.

about james edward scherbarth

James Edward Scherbarth (Jim) was born on Christmas Eve in Minneapolis, MN, the eldest of seven children. Jim traveled and moved with his family several times, living in Minneapolis, Chicago, Atlanta and Detroit. This all provided Jim with an expansive and inclusive view of the world, as well as an endless curiosity about different people, places, culture and art. His plans to become a teacher and an artist were detoured by a tour of duty in Vietnam (1969-1970) and unfolding life events in the seventies which all led to nearly 30 years in the corporate world of telecommunications. Having his fill of "the left brain culture," Jim struck out to reclaim his right brain/creative side.

Now Jim's days are filled with travels and with creative processes making art in various mediums—oil and cold wax, acrylics, mixed media, kumihimo (a Japanese form of braid-making) art jewelry, photography and digital montage. Jim maintains a working studio in the historic Northrup King Building in the NE Minneapolis Arts District, continues his learning, conducts workshops in oil and cold wax abstract painting, and exhibits his work in various shows and venues.

jamesedwardscherbarth.com

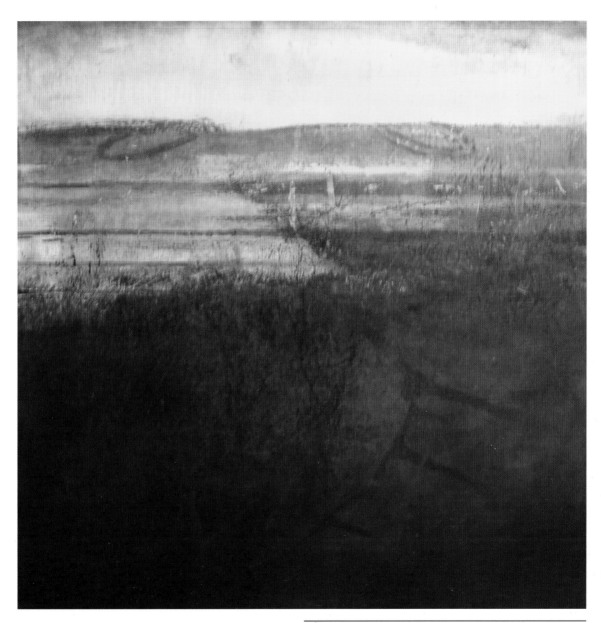

◊ ÉIRE: LA TIERRA DE MIS RECUERDOS
Ireland: Land of My Memories
Oil and cold wax on panel. 30" × 30" (76cm × 76cm)

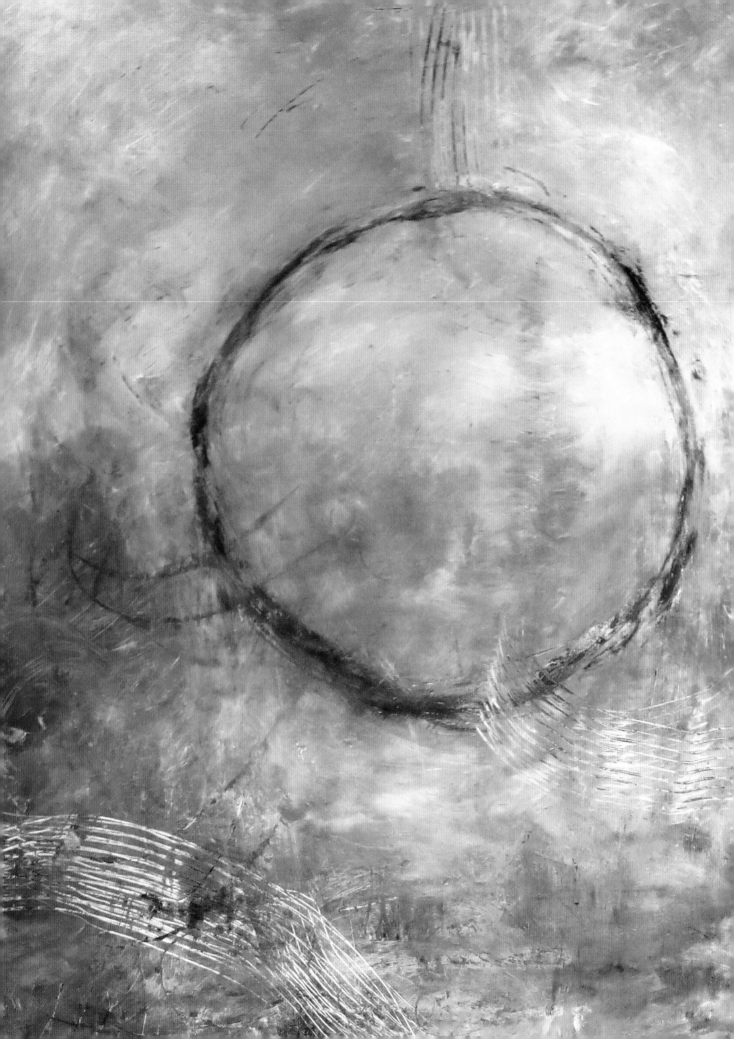

know your medium

Some of you may be new to oil paint and to cold wax. If you are used to using water-based media, oil paint might seem a little overwhelming. It can be messier, stickier, it's slow to dry and has a strong smell. However, oil paint's drawbacks are also its strengths. I love wet-on-wet painting—being able to rework a piece while it is still wet. I love having the ability to blend colors directly on the support in amazingly subtle ways.

Unlike acrylics, which are manufactured from synthetic substances, oil paints are organic in nature. (A minor point for my messy cohorts—it's a lot easier to get oil paint out of your clothes than it is to remove acrylic!) I'm not against acrylic at all. I use it a lot for my mixed-media work. Using both kinds of paint is like being able to drive both automatic and standard transmission cars. Only oil paint, however, can be used with beeswax-based media. So for hot or cold wax work, oil paint it is!

The term *cold wax* gets a lot of people confused. How can you paint with wax if you don't heat it, as we do with encaustic? Is cold wax a form of encaustic? Is it a new invention?

Some type of cold wax has been used as a medium since ancient times. A form of cold wax was used, as was encaustic (melted beeswax and resin) to create the famous "mummy portraits" unearthed at Fayum in Egypt. Modern cold wax is a creamy paste consisting of beeswax, mineral solvents and resins. It adds thickness to your oil paint, extends the paint and dries to a matte surface with a slight natural sheen. It makes oil paint even more malleable. Because it is in paste form, you don't have to melt it or heat it.

Cold wax helps an oil piece dry more quickly. It can be used straight from the jar or thinned with a little mineral spirits or oil painting medium. (Oil painting medium is a viscous liquid that adds translucence and sheen to the paint and thins the cold wax.) Cold wax isn't a form of encaustic, as the word encaustic refers to the fusing process of layers of wax. Cold wax is a unique medium.

Really, the best way to understand this medium is to get in and try it out. So here we go!

◄ CONTINUITY
Oil and cold wax on panel. 20" × 16" (51cm × 41cm)

the creative process

This piece came together during the photo shoot for the steps in this book. You can see this piece in various stages throughout the book in some of the step-by-step photos. The piece came to the photo shoot with several layers of reddish-brown oil paint and cold wax. Over the next few days, I added layers of blue, white and dark brown. I used an oil pastel to scribble and used a black oil bar for accents. I added a collage element of my handwriting on tracing paper. I also used a stencil to create designs and texture in areas of the piece.

DETAIL ▸ **AN AIRY HABITATION**
Oil, cold wax, oil bar, oil pastel, graphite and collage on panel.
14" × 11" (36cm x 28cm)

PREPARING YOUR SUPPORT

Oil and cold wax artists generally use a rigid support, such as birch panels rather than canvas. A rigid support allows you to use more cold wax per paint. If you do this on canvas, the paint is likely to crack. A rigid support also allows you to incise more deeply into the paint layers, as you'll see later on. Artists who use a smaller ratio of wax to paint (about 30%-40%) or who thin the paint and cold wax mixture may still choose to use canvas. I will show you several ways to prepare a panel for painting.

Materials

acrylic gesso

acrylic paints (optional)

flat wide brush

fine-grained sandpaper

marble dust (optional)

palette knife

wooden panel, flat or cradled

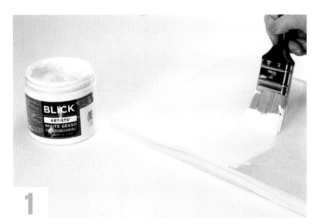

1

Choose a rigid support such as a cradled wood panel. With a wide flat brush, apply a thin coat of acrylic gesso. Make sure the entire panel is covered. Let it dry before applying another layer. (Many cold wax artists apply up to four layers of gesso.)

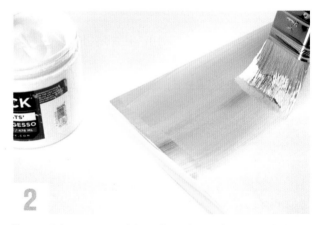

2

If you wish, you can add acrylic color to the gesso before applying it. When the first layer is dry, apply a second thin layer.

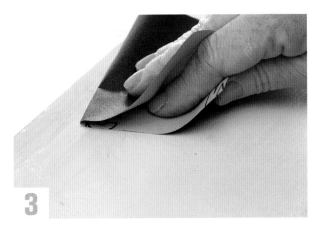

3

When each layer is dry, use fine sandpaper to sand down any unwanted texture.

ADDING MARBLE PASTE

This is an optional step, but fun to experiment with.

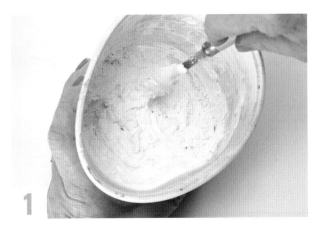

1

Mix marble dust and gesso in a container or directly on the support.

2

Use a palette knife to apply as in the previous steps, sanding after each coat if desired.

USING CERACOLORS

Ceracolors is a new wax-based paint that can be thinned with water. Applied over gesso, it makes a great base for oil and cold wax pieces.

Materials
acrylic gesso
Ceracolors paints
flat wide brush
hair dryer
sponge
water
wood panel, flat or cradled

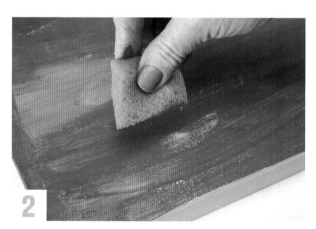

1

Prime the support with gesso. Once dry, mix Ceracolors paint with a little water and apply it to the support with a large flat brush.

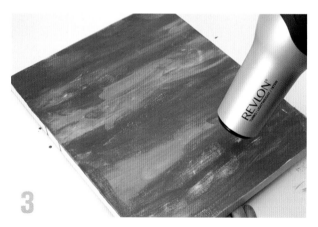

2

If you wish, use a sponge to add some texture to the paint layers.

3

Dry the Ceracolors layer with a hair dryer for several minutes. You may add a second layer of Ceracolors if you like.

USING OIL GROUND

Oil ground is closer to the traditional primer used by artists for centuries before acrylic gesso was invented. If I'm not in a hurry to get a panel primed, I like to use oil ground for its opacity and *tooth*, meaning that it takes oil paint really well.

Materials

flat wide brush

fine-grained sandpaper

oil ground

tube oil paints (optional)

wood panel, flat or cradled

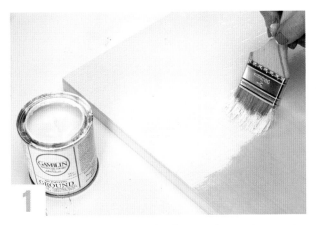

Use a flat wide brush to apply oil ground onto the wood panel. You will need to use short strokes due to the viscosity of the oil ground.

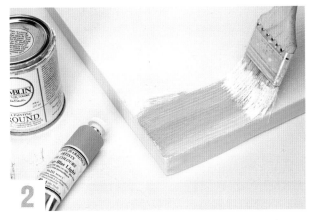

When the first layer of ground is dry, apply a second layer. You can add oil color to the ground by mixing the two in a container or on the support itself. (Oil ground layers take longer to dry than the acrylic gesso or Ceracolor layers.) As with the acrylic gesso, sand after each layer if desired.

Another Primer Option

In addition to these techniques and products, you can experiment with using encaustic gesso for your ground layer. While designed for hot wax work, this ground by R & F Paints works great for oil and cold wax also.

APPLYING VENETIAN PLASTER

Venetian plaster is the most delicious plaster I've ever tried. It's shiny, sticky and smooth. When applied over primer, it allows you to start building in texture right away. Oil and cold wax layers go over the plaster beautifully once the plaster is dry. You can use joint compound in the same way, though my heart belongs to Venetian plaster. (Even the name makes me swoon!)

Materials

acrylic gesso

palette knife or trowel

Venetian plaster

wood panel, flat or cradled

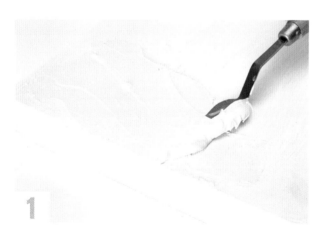

1

Using a palette knife or trowel, apply Venetian Plaster to a wood panel that has been primed with acrylic gesso. Be careful not to make it too thick—this will result in cracking.

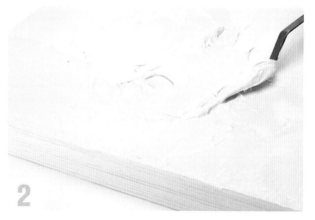

2

You can use a palette knife or trowel to add more texture to the plaster layer as you like. In chapters to come, you'll learn lots of ways to add texture and marks to your oil and wax layers. You can use these in the future for your preparation layers as well.

PREPARING YOUR EDGES

Don't forget to prepare the edges of your support! There are a couple of methods that work well for this.

METHOD ONE

Cover the edges of the support with masking tape to finish later in a color that goes with your piece. You can use acrylic paint for this, but you will want to use a coat of acrylic gesso under the paint.

METHOD TWO

Coat the sides of the piece with the material you used to prepare the support. This can include Venetian plaster and Ceracolor over gesso. As you create your piece, you can extend the colors out onto the sides.

lisa boardwine

When I first saw Lisa Boardwine's work, I was struck by the joy and energy in her painting. Every time I look at her work I am excited by it. Lisa and I share a love of Italy and the never-ending inspiration we find there. I haven't been for several years, but when I see Lisa's work, I feel like I'm right back in Tuscany.

My work is currently inspired by travel to Italy. The textures of worn, weathered walls and eroding architecture, along with the warm color palette of the landscape supply me with continual inspiration.

I begin a painting very intuitively. As the painting progresses, my experiences, memories and emotions begin to guide each work towards its final direction. Thoughts of Italy with its vast array of patinas, graffiti and structures remembered all come together to create my abstract work. My paintings are layered with the emotion I feel for my love of painting and the process. In sharing my journey through paint, my innermost thoughts and feelings are revealed for others to see. Art is a very spiritual experience for me, as one who is a maker as well as a viewer of art.

The experimentation with oil/cold wax has brought me many new tools to paint with. My favorite things are my various scrapers, brayers and my spray bottle, which looks like a work of art itself with all the layers of paint it carries! These tools help me layer, add, subtract, veil and excavate the surface of each painting to reach the desired look I want to achieve. Text, numbers and letters are symbols I enjoy adding on occasion to my work. I use stamps, stencils, collage, and carve directly into the paintings or freehand these elements into certain pieces. The number nine holds a special place in my heart, so in many of my paintings you will find that number semi-concealed in my work.

As well as panels, I use oil/cold wax on paper. My favorites are Arches oil paper and Terra Skin paper, which is made from stone. These papers provide different foundations for the oil/cold wax process and lend themselves to new experimentation and unique textural effects.

Essential for the language of my painting is the layering through texture, mark-making and color to create a history of surface. Painting in oil/cold wax has opened up a renewed love of using traditional oil paint for me. Through building layer after layer, then scraping, digging, veiling and dissolving through, the paintings take on many lives before completion. It is truly a time of play and experimentation in the studio with each work From the initial layers to the final touches, my heart and soul are embedded within these paintings.

about lisa boardwine

Lisa Blankenship Boardwine is an artist/painter living in the southwestern region of Virginia. Her focus is on contemporary abstracts. She works on paper, canvas and panel in a variety of watermedia, oil/cold wax and collage. She has exhibited both nationally and internationally. Lisa's work is included in public and private collections throughout the U.S. and abroad.

Lisa is a Signature Artist member of the Baltimore Watercolor Society and a Signature Artist member of the Virginia Watercolor Society. She offers two- and three-day workshops to art groups and organizations in various locations.

lisaboardwine.com

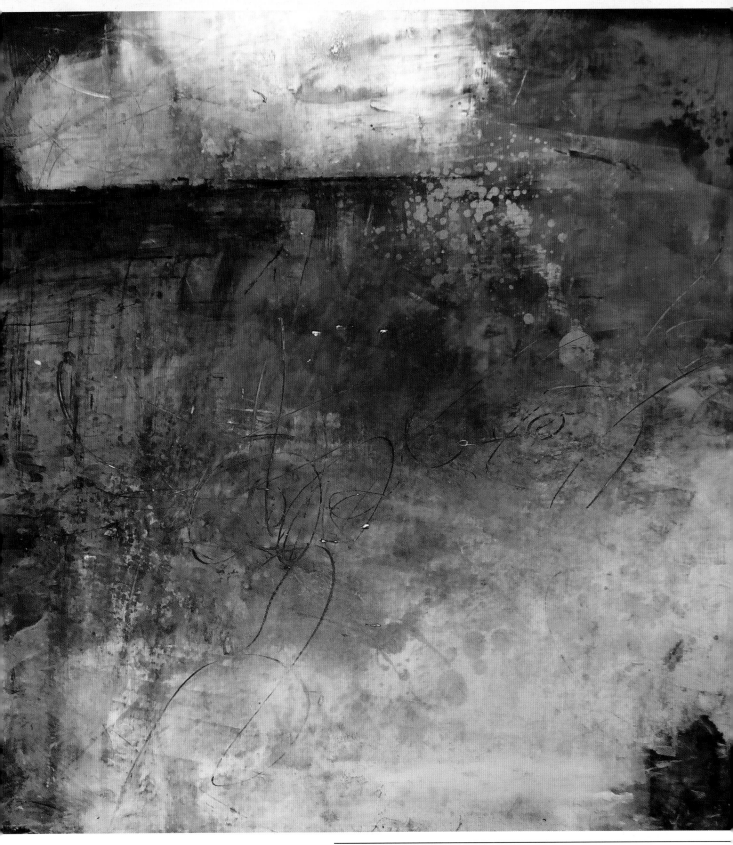

◗ CORTONA SUNSET
Oil, cold wax, pastel and marble dust on panel. 16" × 16" (41cm × 41cm)

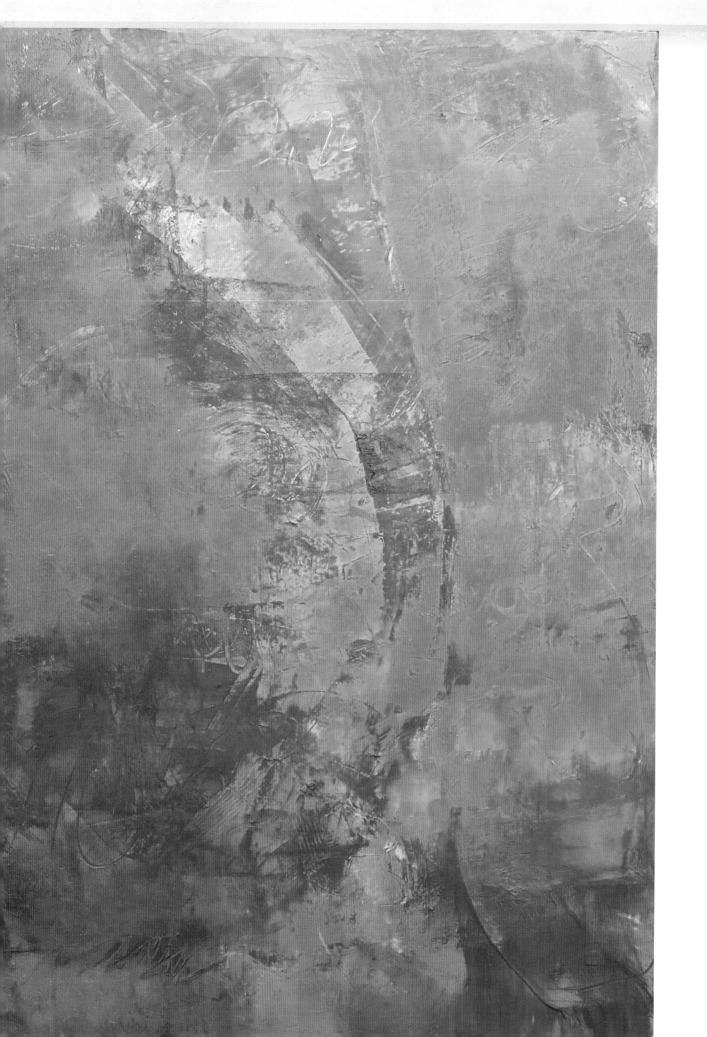

4 layers & textures

Now we've prepared our panels. At this point, you may feel like the little artist in Rembrandt's painting, wondering where on Earth to start. I'm going to make it as easy for you as I can. In this chapter, I'll show you how to apply your initial oil and wax layers. As you make your way through this book, you'll get lots of ideas for ways to add texture to your first layer, but for now, let's just get the oil and wax on the support. I wish I could be there with you to see you mixing the oil and wax and applying it to the panel—it's such a revelation and as easy as frosting a cake.

◄ **PATTERNS OF MIGRATION**
Oil and cold wax on canvas. 24" × 18" (61cm × 46cm)

the creative process

I painted *Patterns of Migration* over an old acrylic painting on canvas. This was an exception as I almost always use wood panels for cold wax work. This canvas was just sitting around supporting a painting I wasn't fond of. I decided to go ahead and use it, but use fewer layers of oil and wax than I usually do to minimize the risk of the wax and oil paint cracking on the canvas.

I didn't have anything in mind before I started. I painted a couple of light layers of red oil and wax using three different reds before I left for a teaching gig in Taos, NM. I completely covered over the original painting and incised into the red layers with a bamboo skewer. I used quite a few of the tools and techniques we'll cover in this chapter to inscribe and texture the piece. When I came back from teaching, the layers were dry. I then went to work with Cobalt Blue oil paint, cold wax and my texture tools.

What appeared on the canvas was, to me, evocations of New Mexico color and light, as well as the history of its peoples. While on my trip, I read an enlightening book on the ancestors of the Pueblo people, sometimes called the Anasazi. The book told of their migrations over several centuries in New Mexico, Arizona, Colorado and Mexico. The feelings of wonder and empathy I had while reading and digesting the book came out in this piece.

I love how that works.

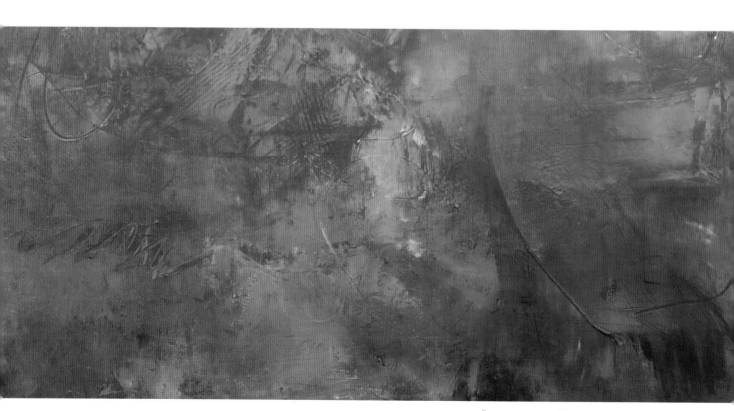

PATTERNS OF MIGRATION, DETAIL

APPLYING THE FIRST OIL AND COLD WAX LAYER

Now we're getting ready to start painting! For best results please note: Dorland's cold wax is made with damar resin and Gamblin cold wax is made with alkyd resin. For archival work, it's best to use only one brand per painting, as the two resins don't mix well in the long run.

Materials

cold wax medium

brayer

bubble wrap

palette knife

prepared panel

squeegee

tube oil paints

waxed paper

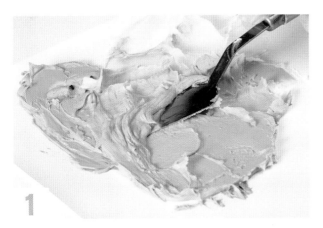

1 On your palette, mix your chosen oil paint color with cold wax medium in a roughly 50/50 ratio.

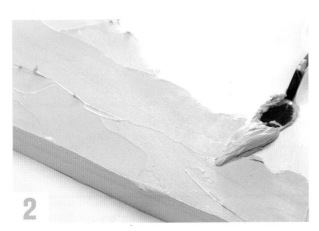

2 Use a palette knife to spread a fairly thin coat of the oil and wax mixture onto your support. Continue spreading the mixture over the entire support, much like spreading frosting on a cake.

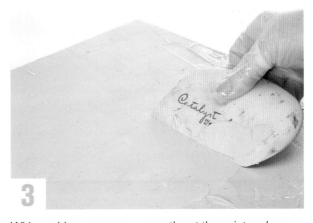

3 With a rubber squeegee, smooth out the paint and wax layer until it covers the support in a fairly uniform manner. Take the excess oil/wax mixture that has adhered to the squeegee and put it on the palette to use later. If you are working on another piece, you can also apply the excess to the other piece.

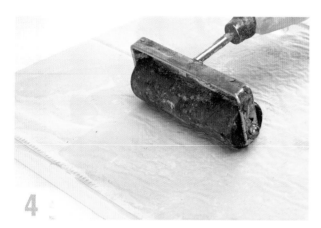

4

Alternatively, you could put wax paper over the paint layer and then use a brayer to smooth out the paint.

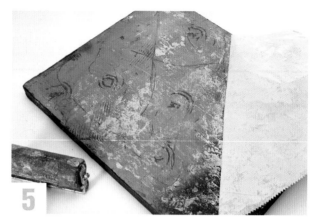

5

The paint left on the waxed paper can be added to another piece in progress, if desired.

stain out!

Gloves and an apron are your good friends. If (when) you do get oil paint and/or wax on your clothes, do not despair! This is where the slow-drying nature of the medium comes in handy. As soon as you can, spray the stained areas with stain remover. Rub the remover in and scrub a little. You should be able to see the stain begin to loosen. Once you've done this, just pop your clothes into the washer and launder as usual.

ADDING TEXTURE

There's no end to the texture and marks you can add to your piece. Most of the tools you'll use are inexpensive items that were designed for other uses. Experiment with them on both wet and partially dry pieces.

Materials

VARIOUS MARK-MAKING TOOLS:

bamboo skewer

bubble wrap

cheesecloth

coffee sleeve

cookie press

meat thermometer

paper towel

pastry cutter

pattern tracing wheel

plastic doily

potato masher

rubber basting brush

rubber jar opener

squeegee

steel wool

wire mesh

Take a piece of bubble wrap (large or small) and press it gently into a wet paint and wax layer.

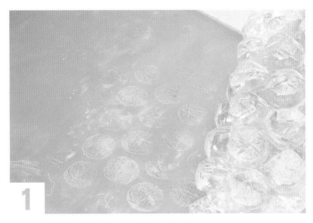

You can leave the bubble wrap texture as it is or soften the marks with a squeegee.

3 Press a piece of paper towel into random areas of the wet paint layer to create texture.

4 Hold a piece of paper towel at one end and gently move the paint layer to vary the texture.

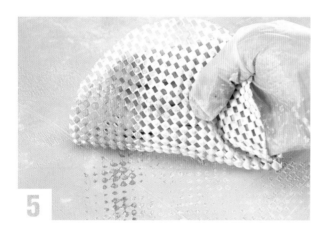

5 Use a rubber jar opener to make small round marks on the wet paint layer. Soften the marks if desired.

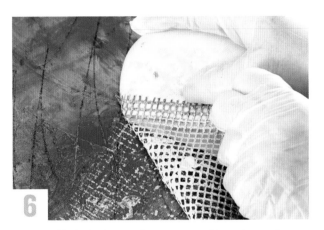

Use any kind of wire mesh to create grid marks on the wet layer or color the mesh to use on a dry layer, as shown.

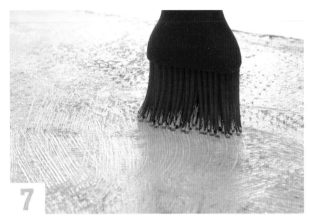

A rubber basting brush will create striations in a wet layer or in one that is partially dry. Whisk the brush randomly over the surface of the support. Some artists use a whisk broom (the straw kind used to clean around fireplaces) to achieve a similar effect.

Use a bamboo skewer to draw text or designs into a wet or partially dry layer.

Use a pastry cutter to create texture on a dry or partially dry layer.

Use cheesecloth to create texture on a wet or partially dry paint layer.

Rub steel wool gently on a dry paint layer to reveal some of the previous layers.

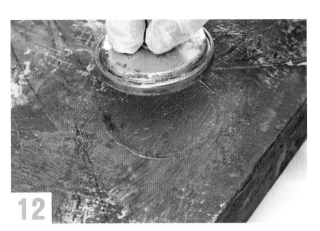

With the round end of an old meat thermometer, incise circles to reveal previous layers.

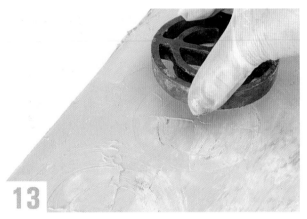

These old metal cookie press parts make a variety of circles in wet or partially dry paint layers.

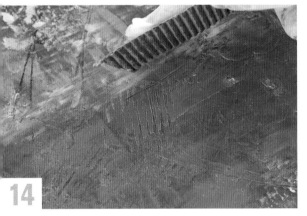

Make horizontal and vertical marks with a coffee sleeve

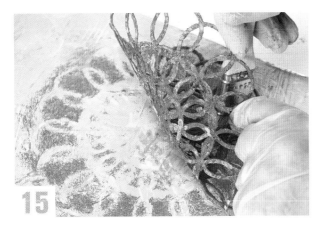

15

Use a plastic doily from the thrift store as a stencil or a texture tool.

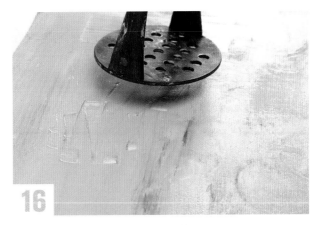

16

This potato masher makes great lines.

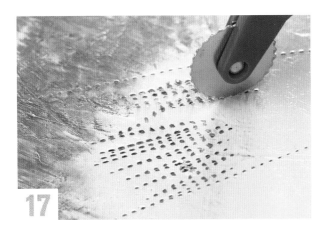

17

A garment pattern tracing wheel makes interesting marks. The tracing wheel can also be used to expose bits of previous layers that have been covered up.

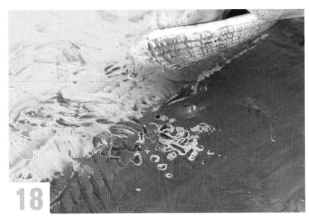

18

Experiment! Don't feel you have to use all these tools in each piece. Play around with them and you'll find your favorites. Some of your marks may be covered by subsequent layers. That's part of the process. Since in many ways your process *is* your piece, all your marks are valuable.

make your own cold wax

Commercial cold wax is convenient, but it's more economical to make it yourself. To make your own cold wax, melt encaustic medium in an electric skillet you keep reserved specifically for this task. (You can buy ready-made encaustic medium or make your own by melting one part damar resin crystals with 6 parts beeswax.) Melt the encaustic medium until it turns to liquid, unplug the skillet and quickly add an equal amount of Gamsol, then stir. Leave the area at this point to escape the fumes. (Wearing a mask when working with melted wax and mineral spirits is a good idea as well.) After an hour or two, you'll find nice cold wax in the skillet. If the wax is too hard, melt the mixture, add more Gamsol and turn off the heat. Again, leave the area until the mixture hardens. If the mixture is too soft, melt more encaustic medium into it, unplug the skillet and stir. The wax does harden as it cools, so you may want to let it sit longer when it seems too soft.

It isn't an exact science, but making my own cold wax has saved me on occasions when I've run out, and all of my town's wonderful art stores are closed. (Where is the twenty-four-hour art store when you need it?)

jacqui fehl

Jacqui Fehl's oil and cold wax work is joyously filled with mixed media and lively movement. Her work has a youthful and exuberant sensibility that I'm excited to share with you. Jacqui is a creative dynamo.

Everything inspires me! Colors, textures, music, emotions, the art materials themselves. Other artists are always a source of inspiration. I will see something that resonates with me and then I will try to figure out how to apply it to my own art. Never to copy, but to incorporate into my own style.

My creative process is mostly intuitive. I may start out with an idea for a subject matter, or a color palette, or perhaps an emotion I wish to convey, but I never really know what the end result will be. Sometimes I play music and other times I paint in complete silence. I always work on more than one piece at a time. Some I complete quickly, and others get put aside or placed in the studio where I can look at them and listen until they tell me what they want to become, or when they are finished. The works I have been most proud of are the ones that "just happened." I'm often pleased by what might be considered mistakes. Sometimes I have no idea what I did or how to do it again.

I love to push the envelope and try new materials. Graphite, oil sticks, tissue paper, loose pigment and India ink to name a few. I love palette knives and bowl scrapers. I also love to incorporate text, scribbles, lines, drips and layers!

It is always a challenge to find time to create. Like many artists, I wear a lot of hats and often get distracted by other obligations. I'm a wife, mother, and I work as a voice-over actress and play in a band—all wonderful distractions. I'm not complaining. I feel quite blessed, but I don't always put in the amount of time I desire into the art studio. This year, I plan to be more disciplined with my studio time. The laundry can wait!

There is a piece of me in all my paintings. Sometimes emotions I didn't even know I had show up in my work. Other times I will pour them out boldly into my work.

When I look back at what I created a year ago, I know exactly what was happening in my life and how I was feeling. I'm always interested when people tell me they connect to a certain piece and why; we share many things as human beings.

about jacqui fehl

When she lived in Los Angeles, Jacqui Fehl took up beadwork to fill the long hours on the sets of television sitcoms where she worked as a dialogue coach and stand-in for child actors. During this time, two of her large beaded art pieces were published and featured in exhibits at the Dairy Barn in Ohio and The Folk Art Center in Asheville, NC.

Since leaving Los Angeles for the mountains of North Carolina, Jacqui's focused her time on raising a family and building her voiceover career. She has since re-discovered her passion for art and is now focusing on painting.

When not making art, Jacqui does voices for animation, toys, on-hold messages and radio and television commercials, as well as making music with her band, Carolina Rex. Jacqui also spends quality time with her family, bakes delicious homemade bread and makes piles of dirty laundry disappear.

jacquifehl.com/art

ALL ROADS LEAD HOME
Oil, cold wax and mixed media on panel. 16" × 16" (41cm × 41cm)

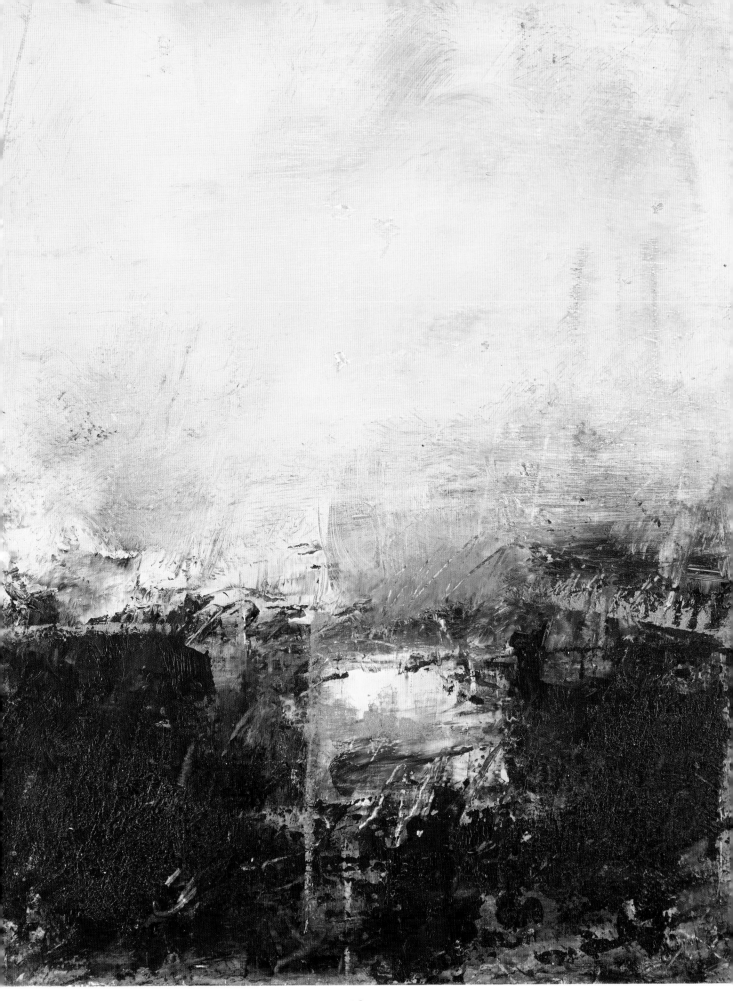

5 dreaming the landscape

O il and cold wax work is well matched to the form of abstract landscapes. Simple even or uneven bands of color can speak volumes when layered and textured in a complex way. A landscape doesn't have to mean trees or other such recognizable parts of nature. A landscape can be a mere suggestion.

In painting, a landscape format can use two or three areas of different colors or different shades. In this chapter, we will explore how to choose and mix colors, low and high horizon lines, wet-on-wet painting, masking, how to abstract from reality, and the influence of memory on our work. I also use the word landscape here to refer to our inner worlds and how these manifest in paint and wax.

◄ **RICH AND STRANGE**
Oil and cold wax on panel. 12" × 9" (30cm × 23cm)

the creative process

A couple of years ago I created several paintings for a group show, and this was the last one. I had more trouble with this one than any of the previous pieces for the show, and time was getting short. The day came when I had to send in my inventory list of the paintings I would be showing. My other pieces were complete and ready to go. This last piece kept hanging around not taking shape. I had to fill in a title for this piece on the inventory form, so I called it, *It's a Mystery*, because it was a mystery to me how I would get it done and what it would look like!

After sending in the list, I spent two full days in the studio getting nowhere. I must have painted about twenty pictures on this panel. Some were fine, but they didn't grab me. One by one, I covered over each attempt. After the second day of frustration, I went to bed early and woke up refreshed the next day. I ate breakfast and immediately went to the studio. I told myself and my panel that I'd had just about enough of this.

I went to work and in less than an hour I had finished one of my favorite pieces ever. This piece sold almost right away. I was delighted that it sold, though I would have liked to spend more time with it.

When I completed the piece, I wondered why my efforts worked one day when they hadn't previously. I still don't know how it happened. I have little memory of painting the piece. It's the magical times like this that make the harder times worth it.

As I write these lines, it occurs to me that the phrase "I've had just about enough of this," reminds me of my beloved grandmother's words on the rare occasions that I tried her patience too much when I was a child. I had so much respect for my grandmother that I straightened up right away when she said this phrase. I didn't feel scolded by her, just that she was giving me valuable information. She knew I could do whatever I put my mind to. Maybe using that firm but still loving tone with myself gave me the freedom and confidence to create the piece. Maybe having the title already in place inspired the soft, misty brushwork that contributes to the air of mystery.

I loaded a brush with Ultramarine Blue, Payne's Gray, Titanium White and cold wax and applied it over the upper two thirds of the piece, which already had several layers, the top one being a Yellow Ochre. I used this mixture as well over a dark layer just below the center of the piece. I brought Ultramarine Blue, Payne's Gray and cold wax down over the crimson layers on the bottom third of the piece. I then used a squeegee to scrape back some of the wet paint to reveal the rich crimson layers. I used a bamboo skewer to incise various areas back to the ochre layer. Other than that, it's a mystery!

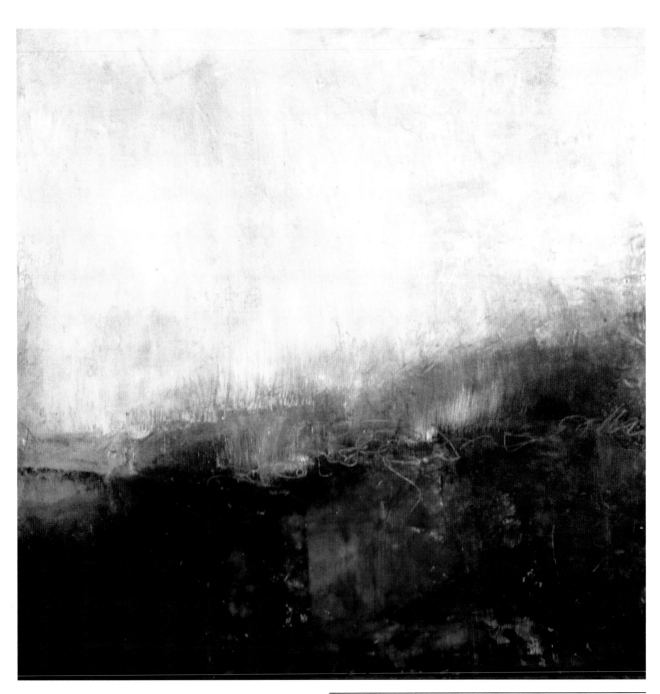

◊ IT'S A MYSTERY
Oil and cold wax on panel. 18" × 18" (46cm × 46cm)

reverse inspiration

A fun way to get ideas for color schemes is to use a photo-editing program to invert the colors of images of your current work. This can give you other color palettes to play with and also let you know what colors work well together. It's also a quick way to see the complementaries of the colors you used in your piece.

These are images of pieces found elsewhere in the book. I inverted the colors of the pieces in these photos and brightened the contrast a bit. I think these color combinations look interesting and worth trying on other pieces.

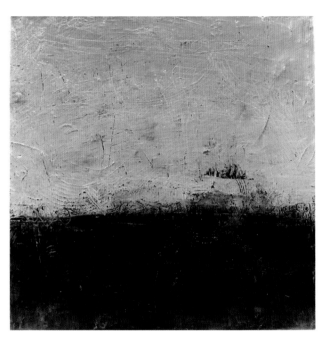

HEART LIKE A WHEEL: INVERTED

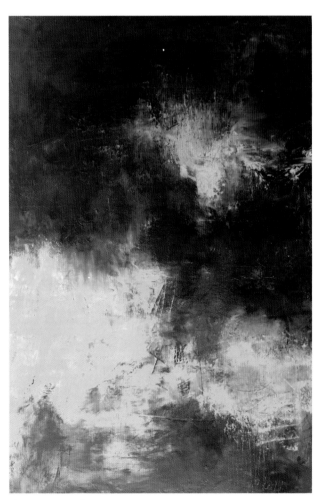

FORTUNATA: INVERTED

memory

We all know how powerful memory is. It can be triggered from any of our senses. I have an old leather overnight case that belonged to my mother. When I open it I can smell her perfume. This brings her presence back powerfully. How often have you heard a song that was popular at a certain time in your life and felt like you briefly traveled back to that time? Memory can inspire you to choose certain colors, textures, and shapes in your work. Our intuitive work gives form to our memories, whether we are consciously aware of it or not.

You can let your memory work behind the scenes as you create, and you can also awaken memory by looking at photographs and videos and collecting music you heard at a time or place you want to remember. Whether your memories are of foreign travels or of childhood dinners, make a point of enjoying some of the foods of that time or place. See if you can find the scent of flowers or perfume that you associate with memory.

When I went to Venice, Italy for the first time it was in July. Lovely though the canals are, they don't smell their best at that time of year. Still, if I smell brackish water now, I'm assailed by the memory of the wonder of Venice!

I find that I work best when I don't try to capture a literal memory in my work, but just let the memories flow through me. If they don't show up in the piece I'm currently working on, they will in a later one.

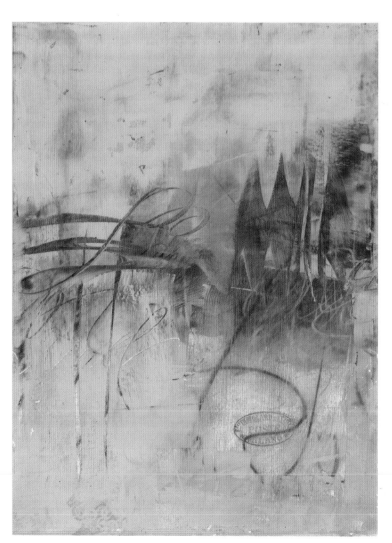

THE CREATIVE PROCESS

I attempted to create a piece that would capture my memories of my grandmother's house and garden, as well as the time period when I stayed there. After several months, I still couldn't accomplish this to my satisfaction.

When I made this piece however, I had no conscious thoughts about that idea. I had finished and titled this piece before I realized that it evoked the memories I'd been trying so hard to make visible in the other piece. The blues are brighter versions of those on the walls of my grandparents' house. The piece evokes the water at the bottom of their garden. The combination of colors, shapes and lines suggests for me the mid-twentieth century, when I spent my happiest days at Grandma's house.

BELIEF
Oil, cold wax, ink and oil pastel on Arches oil paper.
14" × 8" (36cm × 20cm)

CHOOSING AND MIXING COLORS

It's helpful to have a basic knowledge of color theory. A simple color wheel can help you choose contrasting colors for punch, for example. It's also helpful to learn about value (the lightness and darkness of your colors). Explore the internet and art books for information about these elements in addition to trying the experiments below.

Materials

cold wax medium

palette

palette knife

tube oil paints

wood panel, flat or cradled

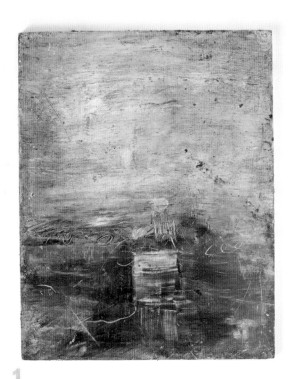 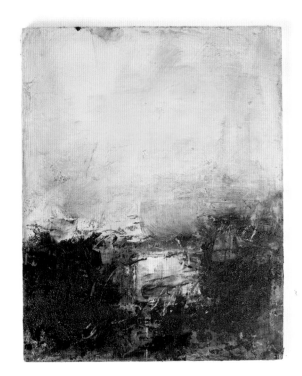

1

Look at your experimental landscapes. Would one or more of them benefit from a stronger contrast of colors?

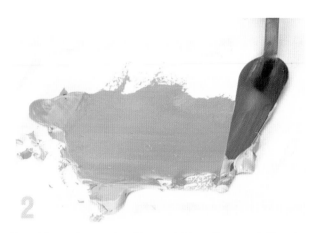

2

Try mixing colors and cold wax right on the panel. Blend the colors unevenly.

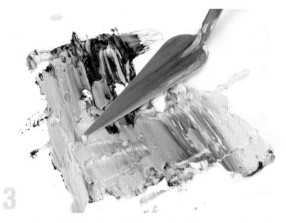

3

Mix a color with Titanium White and cold wax and apply to a panel. Mix the same color with Zinc White and cold wax and apply to a panel. Notice the difference in the tinting power of the two whites. Which might you prefer for a particular piece?

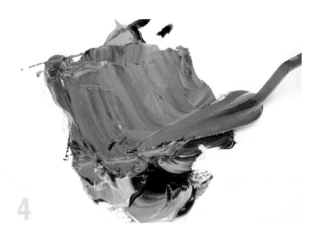

4

Pick a neutral color such as Titan Buff or Payne's Gray. Mix a little of the neutral color in with a brighter color. Take note of the color mixtures you like and jot them down for future reference.

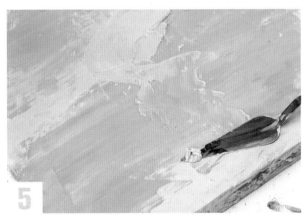

5

As you build layers, try alternating a transparent color with an opaque color. Notice what happens when you reveal some of the previous layer.

EXPERIMENT WITH HORIZON LINES

Horizon lines can be straight, skewed, uneven and suggested.

Materials

artwork in progress (with at least one layer of paint and cold wax)

flat brush

palette knife

squeegee

tube oil paints

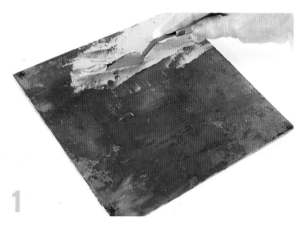

1

Using a piece you have begun, create a high horizon line by adding another color at the top of your piece.

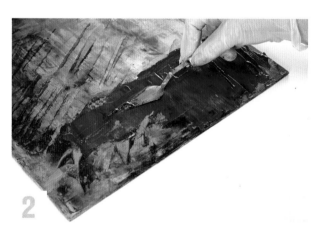

2

Create a low horizon line by adding another color to the bottom of a piece.

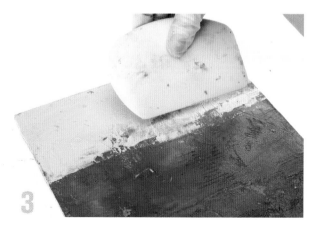

3

Try softening the lines by using a brush or squeegee to blend the horizon area. Play with uneven horizon lines. They can be diagonal or softly varied.

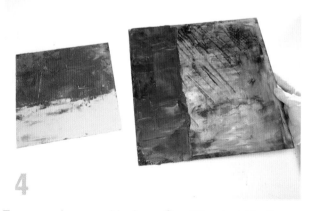

4

Turn your pieces upside down. See if they look like they can go either way. Try them sideways.

MASKING

Follow the steps to learn some easy masking methods.

Materials

artwork in progress

cold wax medium

lightweight collage papers

masking tape

METHOD ONE

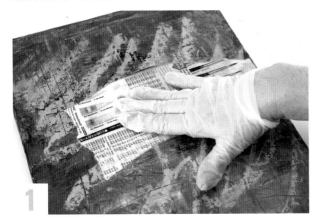

Tear a piece of lightweight paper and collage it down with cold wax medium over an area of rich color. (See Chapter 7 for more on collaging with cold wax.)

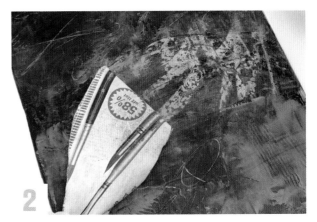

Continue painting for several layers and then remove the collaged piece.

METHOD TWO

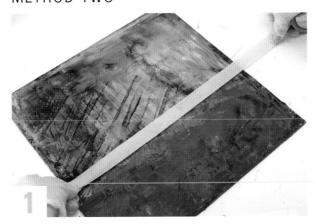

Collage down masking tape to provide a straight line

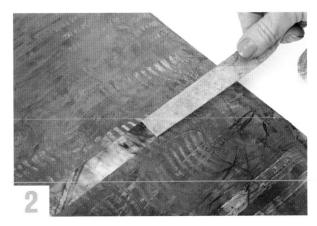

Continue working for several layers and then remove the tape.

WET-INTO-WET PAINTING

Follow the steps to learn how to paint wet-into-wet.

Materials

artwork in progress

cold wax medium

palette knife

squeegee

tube oil paints

various mark-making tools

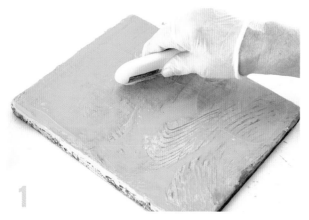

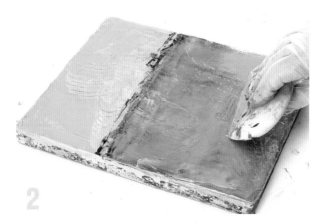

1 Apply one layer or partial layer of color to a prepared support or a work in progress.

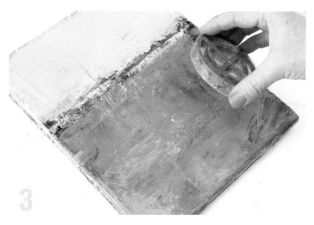

2 Add in another color, blending the two in part of the picture. Take notice as to whether the mixed area seems muddy or enhanced.

3 Use either a palette knife or a squeegee to move the two colors around on the support. Notice the different effects. Use mark-making tools of your choice to add texture as desired.

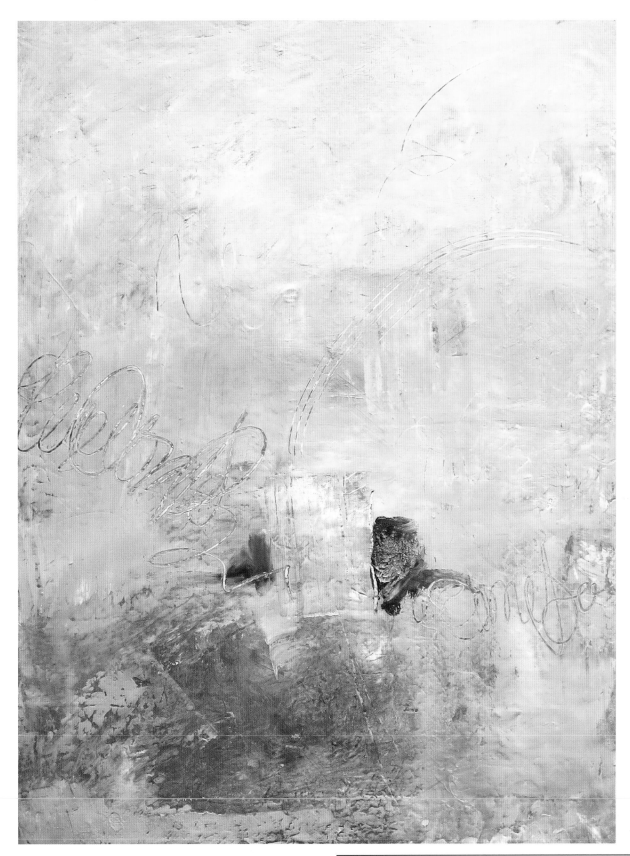

◊ COMING THROUGH IT
Oil and cold wax and on panel. 20" × 16" (51cm × 41cm)

sandrine kern

Sandrine Kern has a way of evoking a powerful sense of place and emotion with her delicate paintings. I was drawn to her work the instant I saw her website. Her compositions are deceptively simple. There's so much going on in her pieces, yet I'm left with a sense of profound peace and well-being when I view them.

My work is inspired by the need to express a very strong sentiment that I have experienced, or that I experience in that particular moment. Most often I begin a painting with a previous idea, yet the final result rarely corresponds to my initial vision.

My favorite medium is oil paint and cold wax. I combine oil sticks, oil paint and cold wax to create a creamy, rich surface rifled with depth. I then further manipulate the surface through the reductive process of scraping away layers with a knife and solvents.

Experimenting and working with a variety of colors and textures allow me to drown myself in the process. The cold wax gives me the flexibility of creating a spectrum of textures and thus a quality of depth within each painting. The translucence that results from this helps me highlight the surface luminosity.

Abstraction allows each viewer the freedom to interpret the painting according to his own experiences. The artist too, is granted the freedom to achieve an expression that is completely pure and unrestricted; one that is a reflection of him. The artist can thus finally be himself. Through the use of abstraction, the painting is the palpable expression of his emotions and thoughts.

Painting is very much an emotional and spiritual process for me. It enables you to escape your own existence and lose the sensation of your body as you progress with the creation of each piece.

about sandine kern

Born in France and making her way to the United States in 1996, Sandrine Kern's artistic roots began at an early age. This was in part from her grandfather's love of painting as well as her own vision of becoming an artist. Sandrine began formal fine-art training in Paris when barely in her teens. She eventually earned her Master's Degree in Fine Art, with honors, from the École National Superior de Beaux Arts de Paris. Her early work was figurative works on paper using oil pastel. She also worked in acrylic on canvas, inspired by Giacometti, Willem deKooning, Egon Schiele, and Jean Dubuffet. Her current work in oil and cold wax on both panel and paper consists of subtle figurative forms veiled in soft layered color.

sandrinekern.com

◊ OUBLIE
Oil and cold wax and on panel. 48" × 48" (122cm × 122cm)

◢ NO RETURN
Oil and cold wax on panel. 12" × 12" (30cm × 30cm)

6 compose yourself

omposition is a vital part of each piece you create. Some of you have likely studied composition in classes, while others are learning as you go. Either way works. We played with horizontal compositions in Chapter 5. Other basic composition forms are:

- Pyramid or triangular
- Cruciform (intersecting horizontal and vertical areas)
- Vertical
- Diagonal
- Circular

Many pieces will have elements of several of these with one form predominating. Other elements to consider in composition are repetition of color and shapes, areas of movement and areas of rest, variation in size and shape of elements, contrast in color and value, balance, and asymmetry.

In this chapter, we'll look at some compositions that you can try both in basic form and varied and combined in a particular piece. We'll also cover techniques for embellishing your pieces, specifically those that are useful for adding interest and depth to pieces that have simple compositional forms.

THE CREATIVE PROCESS

I layered several colors, predominately red and blue, onto a prepared panel. I applied some of the layers using a stencil to create an all-over complex design. I ended up with some nice all-over stenciling but wasn't sure what to do after that. After a few attempts to add to or tone down the piece, I decided to use white and off-white to cover the piece, scraping back with a squeegee to reveal some of the stenciled area below. The reddish stenciled areas contrast strongly with the white and off-white areas. There are also areas that repeat, such as the three main sections where the white is pulled back to reveal the stenciling. The stenciled design and other texture marks add interest and movement to a simple composition.

abstraction of reality

An abstraction is a suggestion of a place, an object or a mood. You can abstract these elements from reality by focusing on color, shape and composition. You may abstract from real life, photographs, remembered experience, observations and emotions. The abstraction I created in this piece was somewhat unintentional. I made the central image of the piece by using the collage masking technique you learned in the previous chapter. Images of the Utah rock formations I'd recently seen were close to the surface of my mind, so when I removed the paper from the central collaged area, I saw the color and shape of the rocks.

Try abstracting from one of your inspiration photos. You may find that your design represents or suggests something that really exists, like these rocks. You may find that you've created a non-representational piece—an image that suggests emotion but doesn't correspond to any object in the physical world.

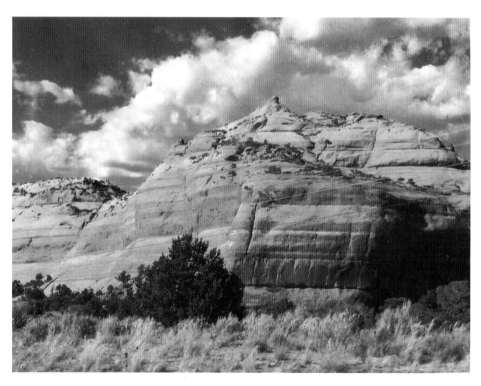

REFERENCE PHOTO—MOAB, UTAH

▶ MOAB
Oil, cold wax and collage on panel. 14" × 10" (36cm × 25cm)

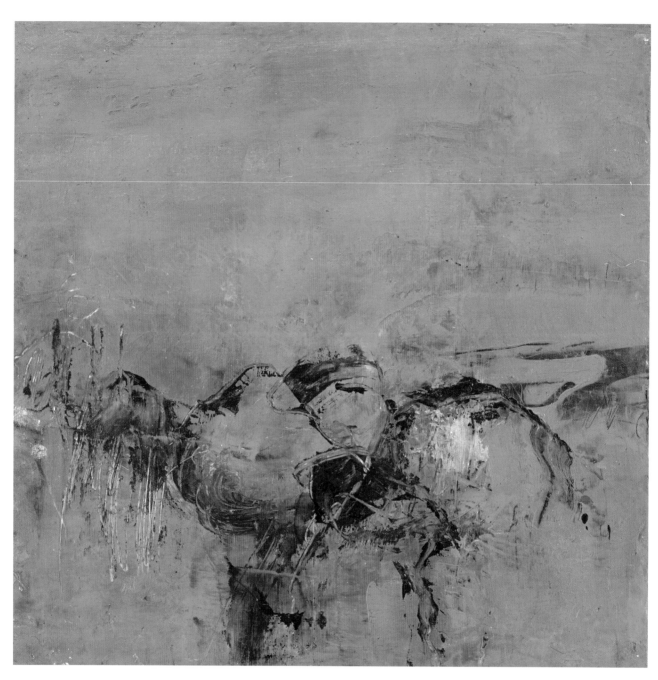

◊ IT'S STILL LIFE
Oil, cold wax, pastel and marble dust on panel. 12" × 12" (30cm × 30cm)

A Non-Representational Piece in
landscape Form

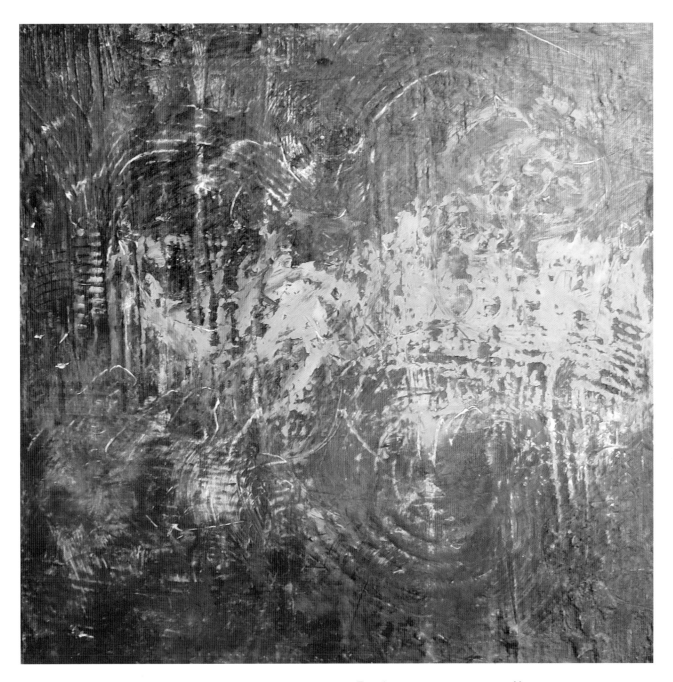

⬥INSOUCIANCE
Oil and cold wax on panel. 12" × 12" (30cm × 30cm)

THE LANDSCAPE FORMAT IN MOTION

This painting combines a landscape format with circular elements. I added vertical touches by spraying mineral spirits on the support to make the paint drip down in some areas. I was in an insouciant mood when I created it, as in, "I don't care if this one turns out." This is, of course, why it did turn out.

USING AN INSPIRATION PHOTO

Horizon lines can be straight, skewed, uneven and suggested.

Materials

cold wax medium

palette knife

reference photo

tube oil paints

various mark-making tools

wood panel, flat or cradled

1 Using one of your photos as a starting point, lay on paint and wax in the shapes and colors of the elements in the reference photo.

Diversify and Unify

If you find composition challenging, keep going! Soon you'll be more skilled at seeing what looks "right" to you. I like to think in terms of different and similar. Are there areas of difference in your piece and areas of similarity? For example, movement and rest, large and small, light and dark are all differences that contribute to an effective piece. Similarities of color, line and shape serve to unify the piece. Look at other artists' work. What makes a piece work for you, the viewer, in terms of composition? Think about how you can invite the viewer's eye to travel around your piece. For example, make sure there is an element of interest in each quadrant of the piece, though these elements don't have to be equal in size, shape or color.

2

Hold or hang the support away from you to see if the composition holds up in paint and wax. Is the piece as a whole too busy? If so, add some calmer areas.

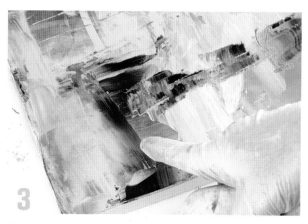

3

Check to see if there are any areas that look too empty. Add or subtract elements as desired.

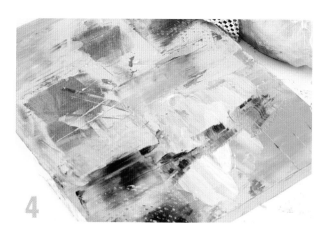

4

Add texture as desired. After the piece is dry, move it sideways and upside down. Note which ways are more pleasing to you. Add or subtract elements as you feel necessary.

EMBELLISHING

Stenciling and combing different texture effects with purchased tools adds richness to your work. Follow the steps to learn various techniques for embellishing your art.

Materials

artwork in progress

cold wax medium

faux texture brush

latex gloves

paper towel

piece of yarn or string

plastic comb

squeegee

stencil

tube oil paints

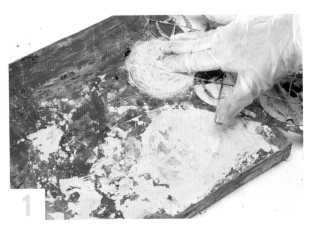

Using a stencil, push a paint-and-wax mixture into the support with your gloved hand.

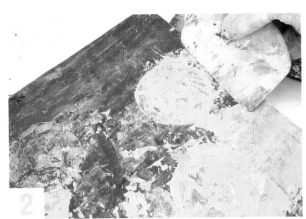

Lightly soften the stenciled image by picking up some of the paint with a paper towel or squeegee.

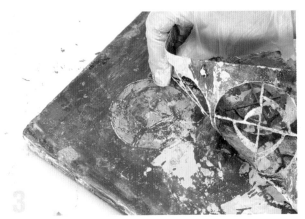

Turn over the paint-covered stencil and press it onto a different area of the piece.

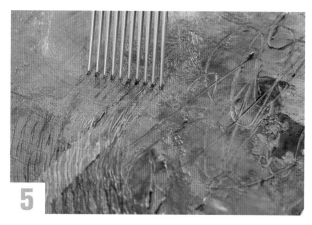

On a surface with wet paint, press a piece of string or yarn into the paint and wax layer. Gently soften the impression of the string as desired.

Use a plastic comb in a wet paint layer. Create free–form designs or use it to make accent marks.

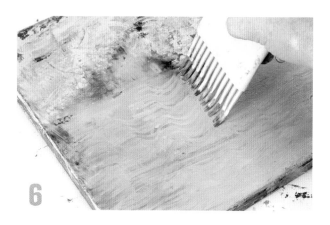

Use a faux texture brush to make lines and waves in a wet paint layer. (These brushes can be purchased at a home-improvement store.)

nicola morgan

Nicola Morgan amazes me. She is able to create extremely complex work that is balanced and exciting, as well as soothing. I never tire of looking at one of her pieces, as there's so much to see.

Painting is very meditative for me.
I have many inspirations through my daily experiences and interactions with the world. However, they often do not translate directly into my paintings as sometimes intended. Teaching would have to be top of my list of inspirations. By verbalizing my approach to painting, I often reaffirm a belief in myself and my work. I am amazed with the various translations and creations that come from my students. It helps me a lot. However, I have to honestly say that it is the process of applying paint to substrate that excites me the most, expecting the unexpected. I often have intentions for a painting based on palette choice. However, because I work on many layers that build upon each other, I usually (and happily) lose my way.

Sometimes I have to give a piece some time to create its own presence. Then I will return to it. What makes good visual sense one day will not always be clear the next. I have a few personal tools that help me to see a piece with fresh eyes. My favorite tools are bowl scrapers (a must), paper towels, exciting textural objects, oil sticks and bamboo skewers.

Working on projects with children has greatly influenced my work, through their unbridled enthusiasm as well as spontaneous approach to form, composition and of course, color. I have always greatly admired a child's way of creating and quickly moving on to the next painting, drawing or whatever activity it is they are engaged in at the time, often without so much as a glance back. Brilliant!

about nicola morgan

Nicola Morgan was born in Victoria, British Columbia, Canada. She now lives and works in Vancouver, British Columbia. She studied at Banff School of Fine Arts, Langara College, and Emily Carr College of Art and Design. Nicola has shown in numerous solo and group shows and has illustrated five children's books. She has been active in numerous arts organizations. In 2012, Nicola worked with children living with Type 1 Diabetes to create an amazing collaborative art piece called *Taking Flight.*

Of her art, Nicola says, "For me, the process of art-making is as personal as it is mysterious. It is an action of surrender through paint, to a world where time is suspended and layers of newly found realities are discovered."

nicolamorgan.ca

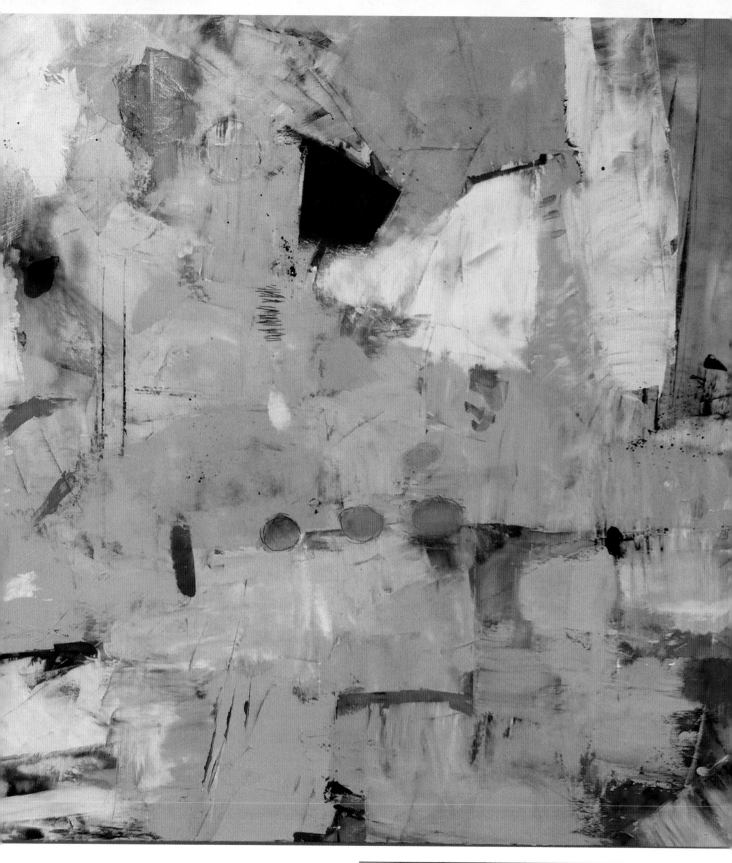

BEYOND BLUE
Oil and cold wax on panel. 24" × 24" (61cm × 61cm)

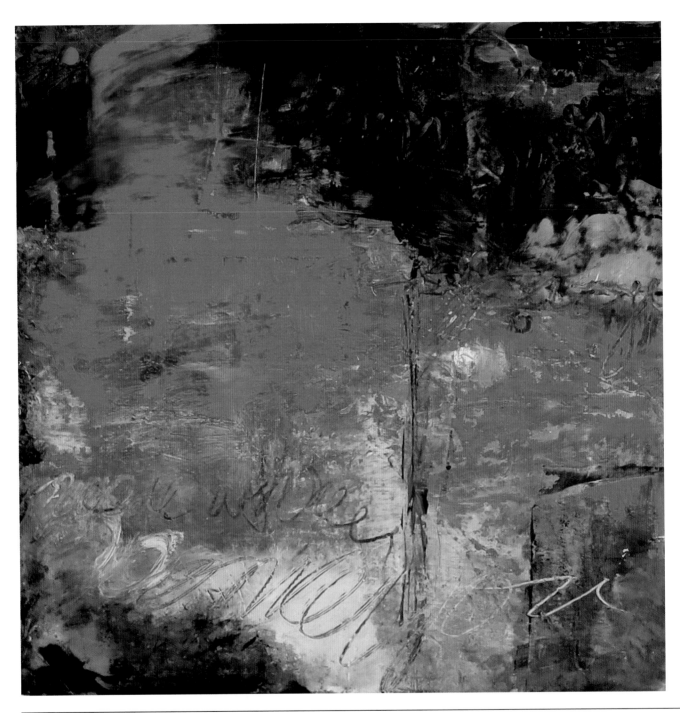

⧫ ONCE YOU WERE WITH ME
Oil, cold wax, marble dust, oil bar and gilders paste on panel.
12" × 12" (30cm × 30cm)

7 Papers, Powders & Paste

Collage is dear to the heart of many artists. Students often ask me if collage can be used with oil and cold wax painting. The answer is a resounding, "Yes!" We'll explore collage elements in this chapter along with powdered pigment, powdered graphite and gilders paste. These stunning elements can enhance your cold wax work in both planned and unpredictable ways.

We will start with collage. When using collage with oil and cold wax, you'll want to choose very lightweight paper. Vintage rice paper, tracing paper, art tissue paper and lightweight vintage book pages all work well for collage with oil and cold wax. The cold wax acts as your glue. Oil and cold wax take some time to dry, so you'll have to wait a while before your collage element becomes an intrinsic part of your piece. I like to use collage elements in a subtle way to enhance the painting I've done, but not to overwhelm it.

We'll also explore techniques for using powdered pigment, powdered graphite and gilders paste to enhance and add interest to your artwork.

Adding Texture and Reflecting Light

I used gilders paste on several areas on the bottom part of the piece and on a couple areas on top. The paste glows when the piece reflects the light. I added marble dust to the red areas to make the paint-and-wax mixture thicker. I scraped back and incised in several parts of the painting. The blue patches were made with an oil bar. The title came from a line in a song I was listening to in my studio while working on the piece. The song wove its way into the painting.

the creative process

The day before I created this piece, I finished reading a book about Van Gogh forgeries. I can see I had Vincent in my mind somewhere when I chose these colors. I began the piece with textured layers of blue, orange, yellow and red. I mixed a chartreuse color for the next-to-last layer. Then I added Cobalt Blue unevenly mixed with white and marble dust on the lower part of the painting. I made the designs in the center and upper left of this piece by scraping back to previous layers with a pottery scraper. The lines in the blue area were made with a bamboo skewer. I felt very playful as I did this archeology. The text-like scraping in the center doesn't really say anything. One friend suggested "Radicchio" as a title because that's what she saw in the "text." Another suggested "Buccaneer," and I liked that one, as I felt like an adventurous buccaneer when I painted this.

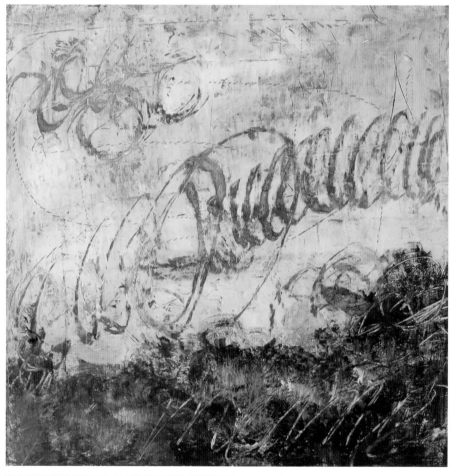

▲ **BUCCANEER**
Oil, cold wax and marble dust on panel. 12" ×12" (30cm × 30cm)

collage adds interest

For the top layer of this piece, I mixed two shades of red oil paint with cold wax and applied it with a palette knife. I then used the knife to mix red powdered pigment with cold wax and apply it to the piece. The reds consisted of an orange-red, Cadmium Red and Alazarin Crimson. I used a squeegee to move the paint and wax layer around, letting the collage elements show through in a subtle way.

The lower part of the piece shows a mixture of yellow and orange paint with wax. Above this area, I used a bamboo skewer to scrape away to previous layers. I pressed the skewer into the paint in a few areas to make vertical lines. I also made vertical lines with the edge of a squeegee. I used small sections of a rice paper vintage account book underneath the top layer of paint.

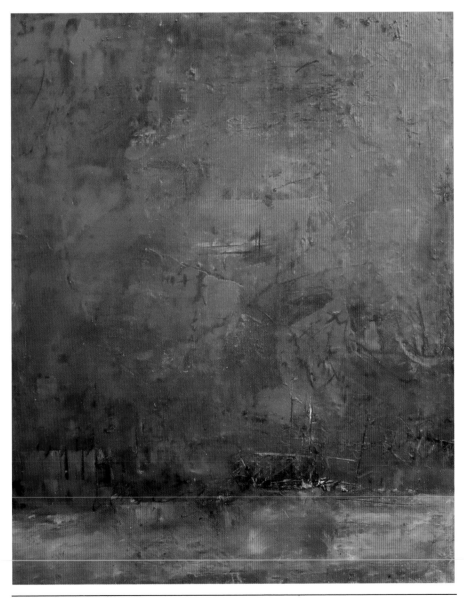

◢ ALL OF A PIECE
Oil, cold wax, powdered pigment and tracing paper on panel. 14" × 20" (36cm × 51cm)

COLLAGE

Follow the steps for adding collage elements to your piece. Try these same techniques on various pieces using old book pages, tissue paper and dress patterns.

Materials

artwork in progress (dry)

brayer or squeegee

cold wax medium

palette knife

tracing paper or lightweight collage paper

tube oil paints

On a dry support, use a palette knife to coat the area to be collaged in cold wax medium.

Take an image on tracing paper or lightweight collage paper and press it into the area coated with cold wax medium.

Using a brayer or squeegee, burnish the image so that it lies flat. Coat the top of the image with cold wax medium.

If desired, soften the edges of the collaged area with a paint-and-cold-wax mixture. If the paper starts to come up during the drying process, press it down firmly and add more cold wax on top. If a collage element is stubborn, peel it off and add more cold wax where you want the piece, press it in again and put cold wax over the top.

POWDERED PIGMENT

If you want an explosion of vibrant color, you can mix powdered oil pigment into your cold wax and apply the same way you would apply tube oil paint and cold wax. Follow the steps to learn how to use powdered pigment safely and with maximum effect.

Materials

cold wax medium

palette knife

palette or support

powdered oil pigments

respirator

tube oil paints

Apply a dab of cold wax medium onto your palette or your support. Then dip a palette knife in cold wax medium and pick up some powdered oil pigment from the jar.

Spread the pigment-wax mixture onto the palette or support, making sure to catch all the pieces of pigment in the wax. Wearing a respirator is advised to avoid inhaling particles.

Add some areas of tube oil paint-and-wax mixture to the pigment-mixture areas, if desired. Move the paint around and texturize as desired. Set aside to dry.

GILDERS PASTE

Gilders paste is a form of cold wax containing beeswax and iridescent pigment, which adds an iridescent sheen to your work. It comes in a variety of colors and shades. Follow the steps to learn how to use gilders paste to add exciting accents to your paintings.

Materials

artwork in progress (with at least one layer of oil and cold wax)

cold wax medium

gilders paste

mark-making tools

palette knife

squeegee

tube oil paints

METHOD ONE

1

On a support with one or more layers of oil and wax, cover the surface with gilders paste. If the paste seems a little hard, add some cold wax medium. Use various mark-making tools to incise and add texture as you like.

2

When the gilders paste has dried, continue to layer and texture your piece as desired. Use an incising tool to reveal the earlier layer of gilders paste.

METHOD TWO

1

Use gilders paste as an accent for a nearly completed piece.

GRAPHITE POWDER

Graphite powder apparently has industrial uses, but we're going to use it much like we used the powdered pigment. I like to use an inexpensive brush to paint a mixture of graphite powder and cold wax onto the support. The brush lines show clearly and give the piece a graphic, gestural look. Follow the steps to learn how to use graphite powder to enhance your artwork.

Materials

artwork in progress

cold wax medium

graphite powder

mark-making tools

mineral spirits

palette knife

paper towel

METHOD ONE

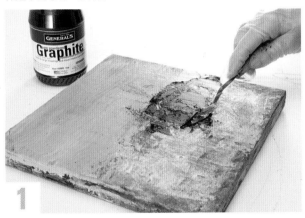

1

As you did with the powdered pigment, apply cold wax medium to your support. Dip a palette knife into the wax and pick up the graphite powder with the knife. Mix the graphite powder with cold wax medium and apply it to your support.

2

Use the mark-making tools of your choice to move the graphite powder around on the support and add texture as desired. Add more wax if needed.

METHOD TWO

1

Add a little mineral spirits to the cold wax-and-graphite mixture on your support.

2

Use a paper towel to rub in some of the mixture. Texturize as desired.

dayna j. collins

I first met Dayna through mutual artist friends. She took a couple of classes from me at art retreats and I was struck by her intuitive ability to create lovely and meaningful abstract work. She has soared in the last few years, developing a signature style that continues to evolve.

I am inspired by rusty, worn out objects, abandoned buildings, varying degrees of patina and well-loved and worn wood. My heart skips a beat with layers, a sense of history and stories told and forgotten.

I love the versatility of oil and cold wax. It has a buttery luminous consistency that I am able to slather on, then scrape portions away. Once it is dry, I can go back and scratch into it and scrape some more, leaving ridges, edges and indentations. When I apply another layer, it seeps into the crevices, creating instant history. When I'm painting, I often feel like I'm going on an archaeological dig unearthing portions of a past life.

Almost all of my work begins with a multi-step process. A base layer of acrylic paint is applied, then a layer of plaster to add interesting texture right from the beginning. The plaster is sealed with a thin wash of acrylic, then I'm ready to begin painting. I paint primarily with palette and putty knives, but I am always scribbling into the wet paint with an ebony or stabilo pencil, a chunk of charcoal, or a bar of graphite. When I want a heavier mark, I use oil bars.

I always begin with a base of plaster, so I have interesting texture to respond to from the beginning. A new technique that I love is using a piece of paper to blot the oil and cold wax. I started using this technique to get excess paint off the substrate, but what I discovered was two-fold: the texture left after being blotted was interesting and diverse, and I could re-blot with the piece of paper over the substrate in other areas, creating pops of color and interesting designs elsewhere on the substrate. My favorite tools, however, are my palette knife and my ebony pencil.

Sometimes I paint just for the sheer joy of painting. But the pieces that truly speak are created when I'm working through issues. There are times when I'm laying down paint and I feel myself getting frustrated, not liking what I'm doing. When I get angry, filled with annoyance at how my painting isn't coming together, I lose some of the tightness in my painting and I begin to paint in more of a frenzy, using bigger gestures, attacking the substrate without restraint.

That is when my paintings get interesting and begin to really come together.

In March 2013, I had a show at the Guardino Gallery in Portland, OR. The title of the show was "Beneath the Surface: Searching for Memory." All the pieces in the show were inspired by my dad's descent into Alzheimer's and dementia. It was cathartic to paint and then tear portions away. My focus was on how memory works in much the same way. We add to it, leave bits behind, create new stories, neglect small details. But what happens when we begin to lose our memory? How do we reclaim the past? Through my work, I invited viewers on an archeological dig, searching the layers, revealing color, texture and what came before. Within these pieces, I left word fragments and decomposing texture, using the concept of pentimenti, where traces and shadows of earlier layers of paintings are revealed.

about dayna j. collins

Dayna J. Collins lives and works in the Pacific Northwest. She is a gallery artist at Guardino Gallery in Portland, OR and RiverSea Gallery in Astoria, OR. Over the past couple of years, she has had solo shows at Guardino Gallery and Lunaria Gallery in Silverton, OR.

Dayna is a member of Artists in Action, the Portland Art Collective an Salem Art Association. She is a founding member of the Salem Art Group. Her work can be seen in two recently published books, *Art Abandonment* by Michael and Andrea deMeng and *The Mixed-Media Artist* by Seth Apter. She teaches a class in plaster called Layers of Memory, as well as an oil-and-cold wax class called Abstracted Play.

For the past several years, Dayna has successfully guided women through twelve-week creative recovery sessions using *The Artist's Way.* She is a certified drug and alcohol counselor and when not making art, she presents workshops on wellness and communication.

alleyartstudio.com

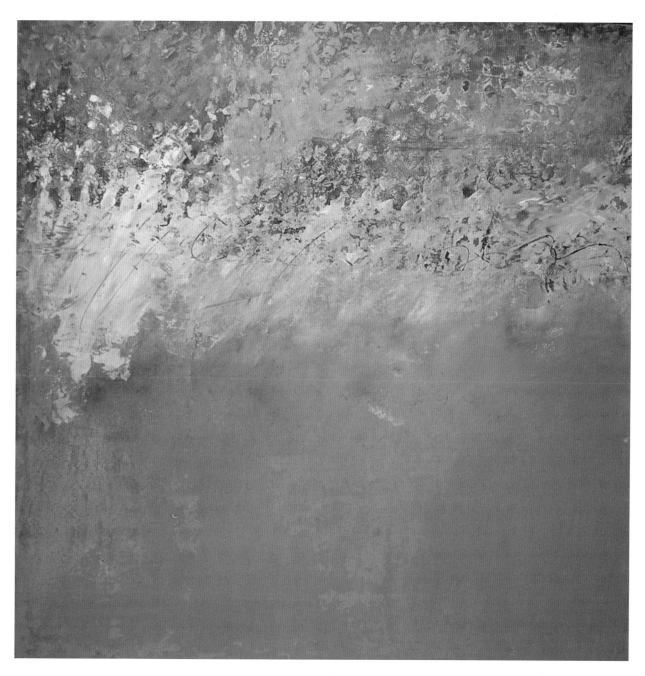

◊ SEEKING REFUGE
Oil and cold wax on panel. 24" × 24" (61cm × 61cm)

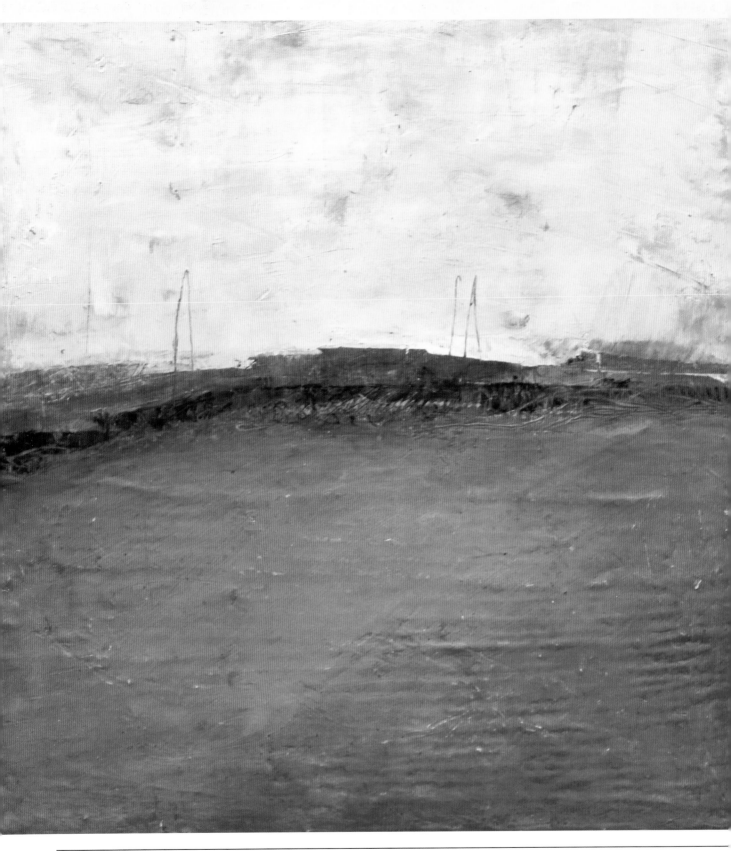

ON THE MARK
Oil, cold wax and plaster on panel. 18" × 18" (46cm × 46cm)

8 mixing it up

Today we artists have more and more media for mixing into our work. In this chapter, we'll take a look at additional oil media for adding rich color and marks. We'll also experiment with graphite crayons, charcoal and an amazing invention called the oil pen. To mix things up further, we're going to throw in some sand. And finally, we'll pick up the humble brush, which we've largely ignored to this point in favor of more unusual tools.

By now I hope you are feeling free and adventurous. Remember, there is no way to make a mistake in this wabi-sabi process. The oil and cold wax layers allow you to cover over and scrape back all you want.

Remember, human beings are a mark-making species. So let's make some marks!

A MATTER OF DETAIL

The blue marks in the piece were made with an oil pen. Though small, they add a lot of punch. I used plaster over the acrylic gesso preparatory layer and dragged a comb through it to create the texture in the lower part of the painting.

the creative process

I created this piece in my women's art group and I'm sure the camaraderie contributed to my free, gestural movements. (So did working on paper, but more on that later.) I scribbled with charcoal and a graphite crayon, embellished with oil pastel color, used a bamboo skewer to dig into the previous red layer, and even used a rubber stamp and ink. (It's only recently that I dared to try using stamps and ink in a painting.)

I was inspired to use three stamps from a set I found at a thrift store. All the stamps in the set have to do with mail. I love the stamps because they have a true vintage look and are not cutesy. The stamped images and the graphic elements suggested the name of the piece. Escríbeme means *write to me* in Spanish and uses the familiar form of address that one would with a close friend, family or sweetheart.

You may notice that there are two kinds of white happening in this piece. I used Titanium White for the more opaque areas. I used Zinc White and a high proportion of cold wax to paint to produce the transparent white areas. To remember which is which, think of Zinc White as the mild-mannered Clark Kent and think of Titanium White as Superman.

I was really happy upon completing this piece because I had let loose in a new way with oil, cold wax and the mixed media elements I added.

DETAIL

In the top area of the detail photo above, you can see how well the bamboo skewer dug into the wet, dark paint to create the exuberant scribble in the red in the previous layer. I used a black stamp pad to echo the black background of some of the piece and the black graphite and charcoal markings.

◗► ESCRÍBEME
Oil, cold wax, graphite crayon, ink, charcoal and oil pastel on Arches oil paper
14" × 11" (36cm × 28cm)

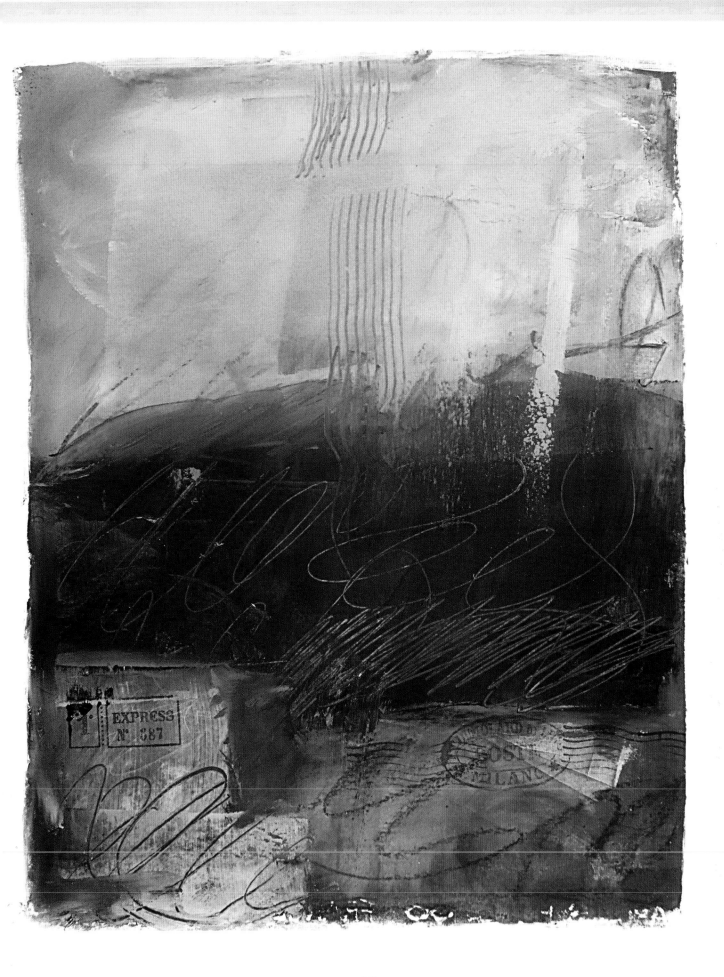

97

OIL BARS

Follow the steps to explore some of the rich marks an oil bar can make.

Materials

artwork in progress

cold wax medium

oil bars

palette knife

powdered oil pigments

tube oil paints

various mark-making tools

1

Use an oil bar directly on the support to create accent marks. Let it dry.

2

With a palette knife, mix oil bar color with cold wax medium. Alternately, you could mix oil bar color with tube oil pigments or powdered oil pigments.

3

Apply the mixture to the support and rub it in and/or texturize with the mark-making tools of your choice.

OIL PASTELS

Follow the steps to learn how to use oil pastels to add texture and detail to your artwork.

Materials

artwork in progress

cold wax medium

oil pastel sticks

paper towel

various mark-making tools

Use an oil pastel stick like you would use a crayon to add script, doodles and shapes to your piece. Let it dry before adding additional paint and cold wax medium.

You can soften the look by gently rubbing the pastel into the support and adding a little cold wax medium. Texture or incise as desired.

GRAPHITE CRAYONS

Follow the steps to learn how graphite crayons can be used to add interest to a piece.

Materials

artwork in progress

graphite crayons

paper towel or soft rag

On a dry panel, make large, gestural lines with a graphite crayon.

Smudge lightly as desired with a paper towel or soft rag.

OIL PENS

Follow the steps to learn how to use oil pens to add rich detail to your artwork.

Materials

artwork in progress (dry)

oil pens

paper towel or soft rag

Use an oil pen to scribble or add small patches of color directly onto a dry painting you have already in progress.

Pick up any unwanted blobs of oil pen color with a paper towel or soft rag. Blend the oil pen color as desired.

CHARCOAL

Follow the steps to incorporate free, gestural marks into your work
with charcoal.

Materials

artwork in progress (dry)

charcoal sticks

1

Use a charcoal stick the same way you would a graphite
stick to make marks on a dry layer of a piece of artwork
you have in progress.

2

You can also rub the side of the charcoal stick onto a dry
layer to get a thicker mark.

SAND

Follow the steps to use sand for adding depth and texture to your artwork.

Materials

artwork in progress

clean sand

cold wax medium

palette knife

squeegee

tube oil paints

various mark-making tools

1

Sprinkle clean sand into a paint-and-cold wax mixture.

2

Apply as usual over dry layers. (You can also add sand to your preparatory layers when you prime your panel.)

3

Move the paint-wax-and-sand mixture around as desired with a palette knife, squeegee or other tool. Texture as desired.

BRUSHSTROKES

The painter's standby, the brush, comes into play. Follow the steps to learn how to use brushstrokes to add interest to your artwork.

Materials

artwork in progress

stiff bristle brush

stiff fan brush

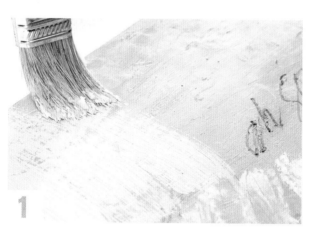

Use a stiff bristle brush to make visible brushstrokes.

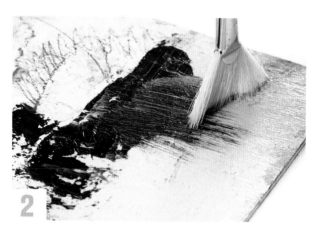

Use a stiff fan brush to draw out small areas of paint and wax.

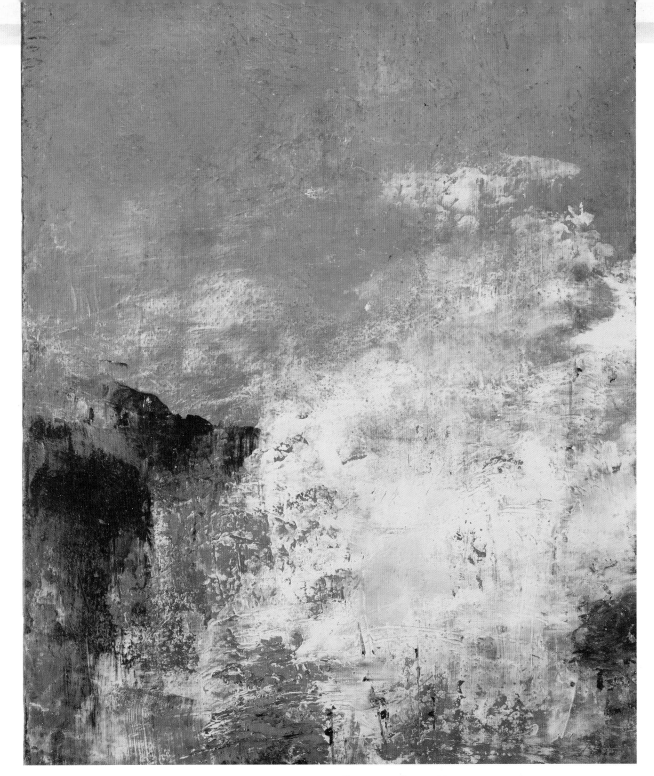

▲ ESSENCE
Oil, cold wax and sand on panel. 14" × 11" (36cm × 28cm)

CREATIVE PROCESS

I used several layers and mixtures of colors with the cold wax and sand until I ended up with a swamp green. I liked the color despite its dubious-sounding name, but wondered what would go well with it. My intuition said, "Try turquoise," even while my logical mind thought that was a disastrous idea. I went with my intuition, and it worked. All the piece needed after that was a dark Umber for contrast. The sand added to the paint and wax layers gives depth and a slightly sculptural quality to this suggestion of ocean, rocks and sand. I see in this piece the accepting solitude of wabi-sabi.

ruth andre

I related to Ruth Andre right away when I discovered her work. I found it interesting that she had fairly recently moved from representational work to abstract work, as I had. Her abstract work evokes a powerful response in me. I'm sharing the twelfth piece in her *War Bonnet* series. The movement is strong, yet the feeling is peaceful.

I'm inspired by living in a small quiet valley which gives me the time not only to see but feel the landscape that surrounds me. The palette of the land with the changing seasons is endless inspiration for my paintings. I paint with a design and palette in mind. It is the seed that transforms itself and becomes its own image.

The combination of oil and cold wax has a wonderful buttery texture and lends itself to textural mark-making. The Princeton Catalyst Wedges are my favorite tools. Each of my paintings has several layers, four being a minimum number.

It seems that the painting process has a way of taking on its own path. When painting, I sometimes feel as if I am being led by some invisible force allowing the paint to move at will.

The *War Bonnet* series unfolded quickly with an energy to tell its story. The wordless story came as an engulfing breeze pushing me along. With each beginning, there was a time to let go and let the paint present its quiet resolution. The mixture of color shown through the quill-like textured ridges and long sweeping shapes translate the migration for the people of earlier times. The land of the Plains and its people have given me the inspiration to paint this series. There was a need to paint these works and "follow the sound of the drums."

about ruth andre

Ruth Andre studied art and design at California State Long Beach and printmaking at Otis/Parsons Art Institute. Her interest in art led her into a career of representing artists and photographers located in Los Angeles, San Francisco and New York. In 1992, she took her first painting workshop with Maurice Larioux in Santa Fe, NM and was hooked. She continued studying on her own and took workshops with well-known artists to learn the art of painting. Printmaking, fiber sculpture and graphic design are all part of who Ruth is, but painting is her true love. She considers her previous careers as very important, since they were instrumental in forming what she does today.

Ruth currently lives in the back country of Northern California. The landscape that surrounds her daily life has become the inspiration for her abstract paintings. "The seasons change and nature's palette travels from dark greens in spring, to golds in summer and finally to white in winter. Each painting brings to the canvas the essence and my interpretation of the inner spirit of my heart. The paint moves from palette knife to canvas, releasing the paint to tell its own story. My hand holds the energy from within as the mixing of the paint colors ignite and nature's beauty emerges."

ruthandre.com

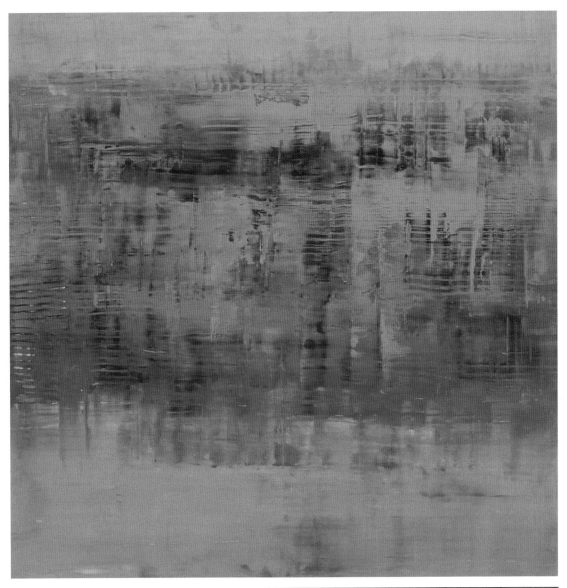

⬥ TALIDU
Oil and cold wax on panel. 16" × 16" (41cm × 41cm)

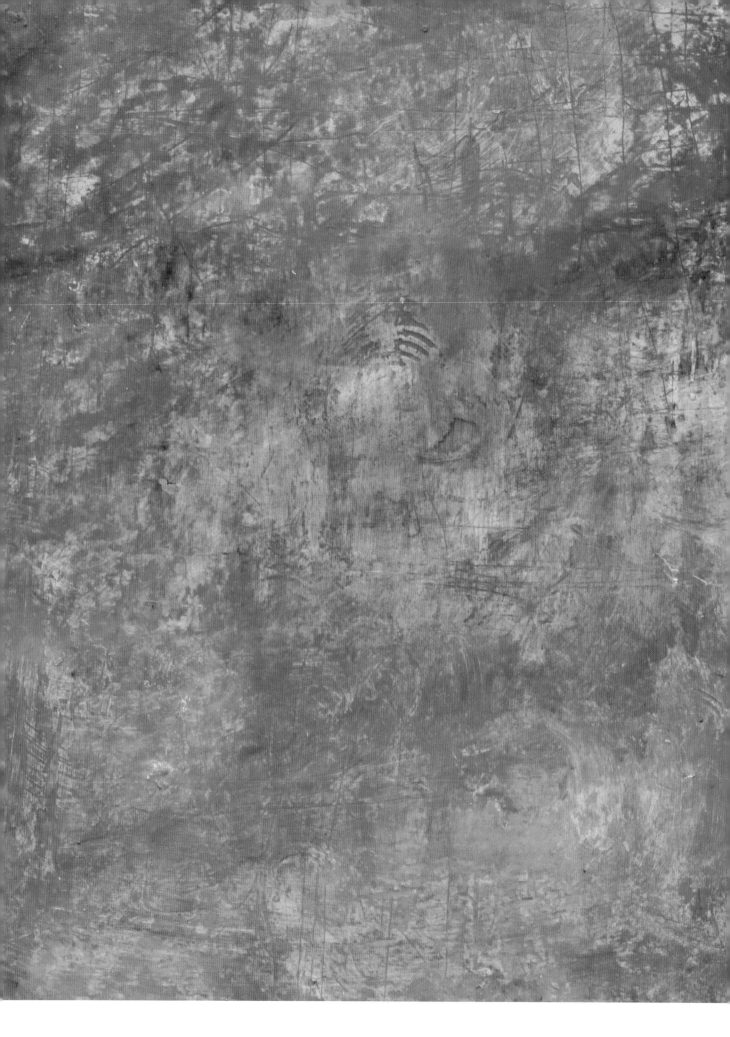

9 lost & found

We artists may be archeologists at heart. We love layers and strata that evoke history and transition. If we ourselves create these layers and then get to excavate them, our joy is unbounded. In this chapter, you'll learn ways to thin your paint and wax layers and how to incise and scrape the layers to reveal what came before.

We'll start by using incising tools to dig deep for treasure in buried layers of your piece. Then we'll move on to thinning the paint.

One product we'll use in this chapter is odorless mineral spirits. This is a modern version of turpentine, used to thin paint as well as clean brushes. My favorite is Gamsol. This product is almost truly odorless and is invaluable for the cold wax artist, as you'll soon see.

We'll also investigate thinning your oil-and-cold wax mixture with a liquid oil medium. These mediums are used by most oil painters to add transparency and luminosity to paint and to extend the paint and strengthen the paint film. Cold wax is an oil medium as well, so we'll be combining the liquid and wax medium to get the effects we want.

Citra Solv is a natural cleaner and de-greaser. As you may know, mixed media artists discovered a while back that this product is also great for transforming National Geographic pages into painting-like collage papers. Oil and cold wax artists have been busy discovering new uses for Citra Solv in their work as well. I'll show you how to use this product to do a radical thinning of your paint layer in selected areas of your piece.

◄ **REALMS**
Oil, cold wax on panel. 20" ×16" (51cm × 41cm)

the creative process

I've noticed lately that a lot of artists have given a piece the same or similar title to *Beneath the Surface*. We artists want to know what's underneath the surface of things. I think of ruins of ancient cities buried under new ones, the remains of Shakespeare's Globe Theatre unearthed, even a king of England found buried under a parking lot.

When I was a child, my father took me to find fossils of shells embedded in rock where there was once an ocean. When he made his first garden in our suburban back yard, he found arrowheads and baked clay marbles made by the earlier inhabitants of our land. What lies beneath the surface tells the story of our earth and our collective history.

At one point in its incarnation, this piece had some golden brown layers that I really liked. I scribbled over these dry layers with a graphite pencil, pressing hard. The piece wasn't finished, so I added a bunch more layers. I don't remember that process—I think I blocked it out! I was left with what looked to me like a mess. I missed my golden brown layers.

Fortunately help was at hand with a bottle of Citra Solv. Even though the unwanted layers were pretty dry, the orange de-greaser was able to loosen them after I sprayed it on the panel. I wiped off the thinned paint as best I could. Then I grabbed my pottery scraper and worked my way down to the golden brown layers and to an Umber layer that showed through in some places.

I used my squeegee to pull back what was left of the paint. I left the marks of the squeegee visible in several areas. Now I had several shades of Ochre and Umber showing, as well as the scribbles I'd put down earlier. I liked what showed just as it was. I did one more thing to the excavated layer—I used the edge of the squeegee to form the semi-circle near the bottom of the painting. After the excavated layers were dry, I covered them with a layer of clear cold wax medium to protect them.

The piece needed contrast. I tried putting blue and white at the top of the piece, and it worked. This piece contains memories of Italy and of Northern New Mexico, places where brilliant light and mellowed stone work magic on my heart.

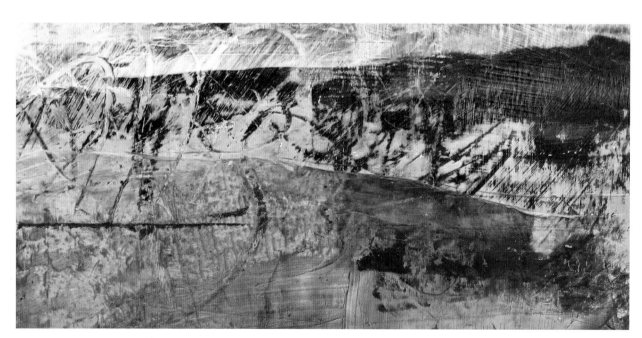

DETAIL

This detail shows incising done with a pottery tool on the early layers of the piece.

Visit www.createmixedmedia.com/coldwaxwabi-sabi for extras.

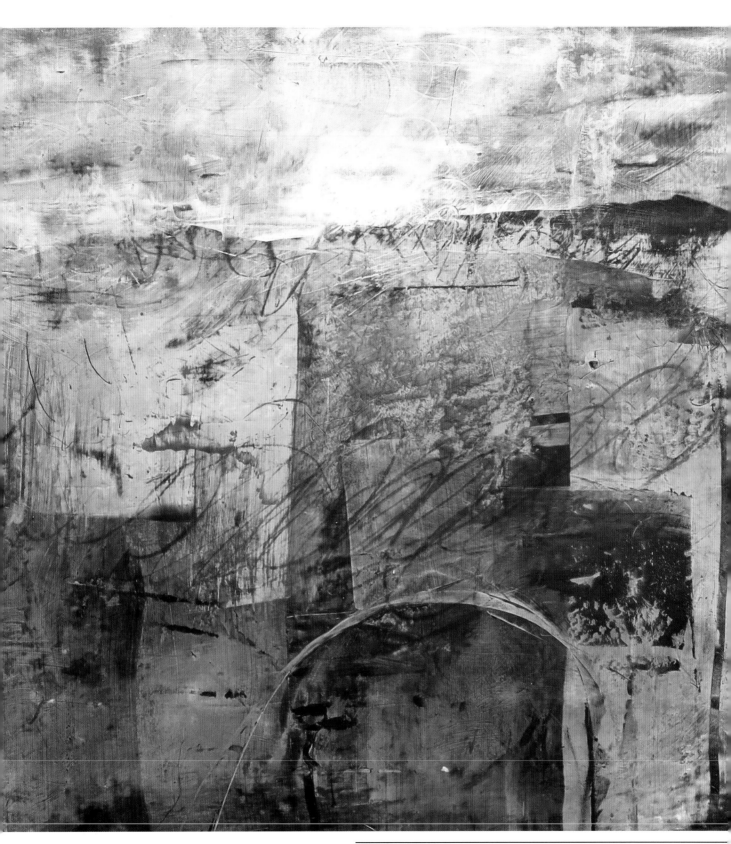

◄ ◊ BENEATH THE SURFACE
Oil, cold wax and graphite on panel. 16" × 16" (41cm × 41cm)

EXTREME ARCHEOLOGY

If you have several layers of dry paint, you can incise rather firmly with a carving tool or a pottery scraper. Just be careful not to gouge clear down to the bare wood of the support. And don't be afraid to experiment! Try mixing one of the colors in your piece with cold wax and layering over the scraped-back areas. This will give a softer look and help unify the piece.

If you decide you don't like something after you've put it down, vegetable oil works great for removing wet paint. You'll need to clean the vegetable oil off your piece as much as possible before going on to the next stage of painting.

Materials

artwork in progress

carving tool

cold wax medium

palette knife

pottery scraper

soft rag

vegetable oil

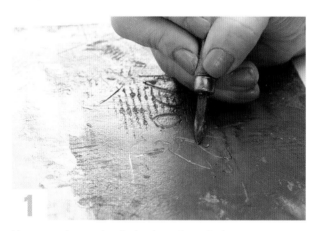

Use a carving tool to incise into dry paint layers on a piece you have in progress. If desired, you can rub another color into the incisions and/or soften the incisions as you see fit.

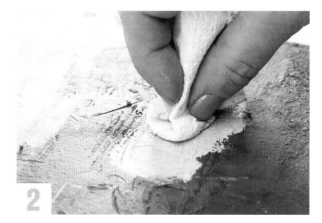

Use vegetable oil and a soft rag to pick up extra wet paint from a specific area.

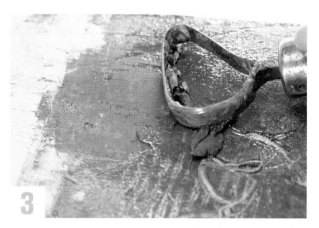

Use a pottery scraper to scrape back to larger areas of previous layers. Use it gently or vigorously depending on how much you want to reveal. When the scraped-back areas look as you want them to, cover those areas with a thin coat of cold wax medium and let dry.

THINNING PAINT FILM

There are a few different materials that can be used to thin paint film. The most common are mineral spirits, liquid oil paint medium and Citra Solv. Care is needed when using mineral spirits or Citra Solv so that you don't remove more paint than you intended. Avoid getting these products on your hands—wear your gloves!

If you like to use a high ratio of cold wax medium to oil paint to increase transparency, you may want to experiment with adding Galkyd Gel Medium (often called "G-gel") by Gamblin to your paint and cold wax. This alkyd resin medium adds strength to your oil and cold wax mixture while keeping the transparent effect.

Materials

artwork in progress

Citra Solv or Gamsol

cold wax medium

eyedropper or spray bottle

latex gloves

liquid oil painting medium

palette knife

paper towel

stiff bristle brush

tube oil paints

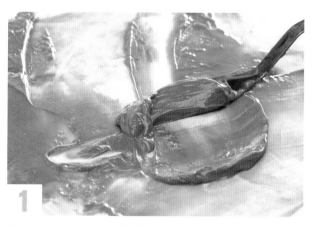

1

Mix a small amount of liquid oil paint medium into your paint-and-cold wax mixture to make a more fluid paint.

2

Apply a small amount of mineral spirits or Citra Solv over a wet paint layer using an eyedropper or spray bottle. Let the mineral spirits or Citra Solv run down the piece, taking some paint along and creating interesting drips. You can also use a stiff bristle brush to apply the thinning agent directly to the support on a partially dry layer. This will loosen the paint and make it more liquid.

3

Use a paper towel to gently blot the thinned areas. If desired, rub a transparent paint into the areas where you removed paint. Add transparent paint and wax layers as desired over the revealed area. Or, you can add a thin layer of clear cold wax over the area and let it dry.

grace carol bomer

I loved Grace's work on first sight. I wrote her a fan message on Facebook where I saw a piece from her *Vessel* series posted. I told her the piece really spoke to me. She wrote back thanking me for the comment and asking me what the piece said when it spoke to me. I told her it said, among other things, "Don't you wish you had painted me?"

Fortunately all any of us can do is our own work, but how wonderful and varied is the work of oil and cold wax artists like Grace! Her deep spirituality is reflected in all her work.

I am inspired by words, images and ideas. Poetry, prose and the Scriptures inspire my work, words that are rich in metaphorical language. Words create images in our minds. And metaphorical words compare one thing to another or make analogies that we can understand. We speak of our lives as a voyage and we compare our lives to a vessel. That is the analogy in this poem, taken from the novel *Island of the World* by Michael O'Brien. His words inspired my *Voyagers/Vessel* series.

"Seek the eternal in the present,

seek the past and the future,

link them with the trajectory of your course,

for you are,

you are,

you are the vessel."

These words stirred my imagination allowing me to "see in pictures." Knowing that the first layers of oil and wax may be scraped away, I began with lighter color, probably Raw Sienna (but I never use color directly from the tube). Perhaps this layer refers to the glory that is often hidden. Then I added a layer of blue oil and cold wax. And finally the dark brown (perhaps mixed with some blue to make it even darker) to add drama. The dark allowed me to scrape back to the lighter Raw Sienna color to form the boat shapes. Random lines and marks were created to add interest and texture as I worked. The scumbled marks made by my dough scraper tool always create mystery. These marks may happen randomly, but usually it is a contrived randomness working with my imagination.

A specific poem may have influenced my *Vessel* series, but a painting evolves in a mysterious way. I may see an image in the wax and develop it into something totally unrelated to the painting. It may take on a life of its own as it reveals mysteries to me. Often I have to push it further because I will see images before I have applied enough layers of paint. I may add scribbles and text or even wipe out something that is too attractive too early in the process. The paradox is that often you must lose it to find it. (Sort of like life.)

I like the freedom of movement with oil and cold wax because of the consistency (like icing or butter) of the wax with the oil—especially using the dough scraper, which allows for large swaths of color. It allows for more large random marks and color and also texture, text and layers to create a history. My favorite tools are brayers and incising tools and the dough scraper by Wilton.

When I create an imaginative unity with materials like oil and cold wax, it has never been done before. It is a new creation that requires the use of my heart, soul and mind.

about grace carol bomer

Grace Carol Bomer works at her studio in Asheville, NC. She also teaches oil and cold wax workshops there. She has shown nationally and internationally in universities, museums and galleries, from the Asheville Art Museum to the Karas Gallery in the Ukraine.

Grace taught and spoke at Luxan Academy of Fine Art in Shenyang China. Currently her work is traveling in Spain with Arte-Fe.

gracecarolbomer.com

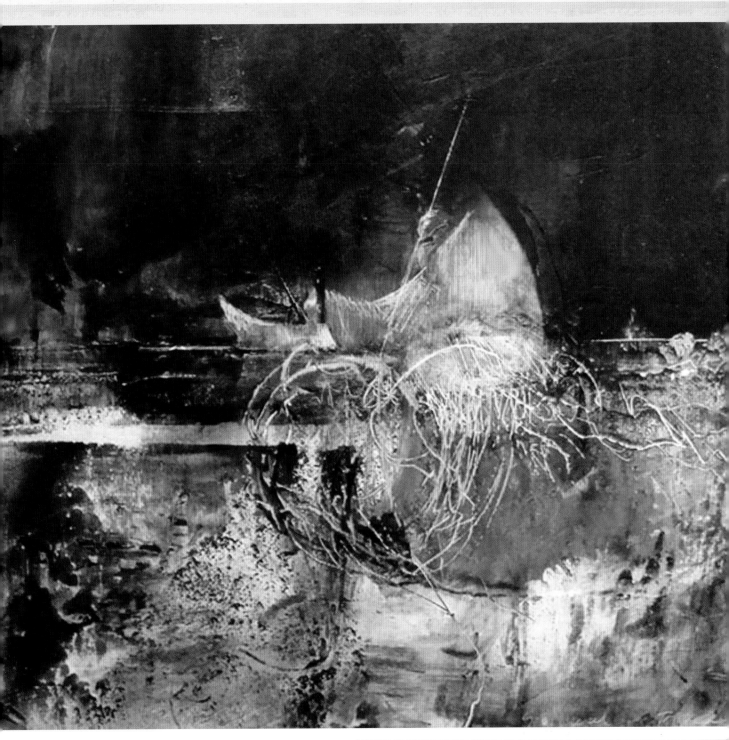

◊ VOYAGERS
Oil and cold wax and on panel. 12" × 12" (30cm × 30cm)

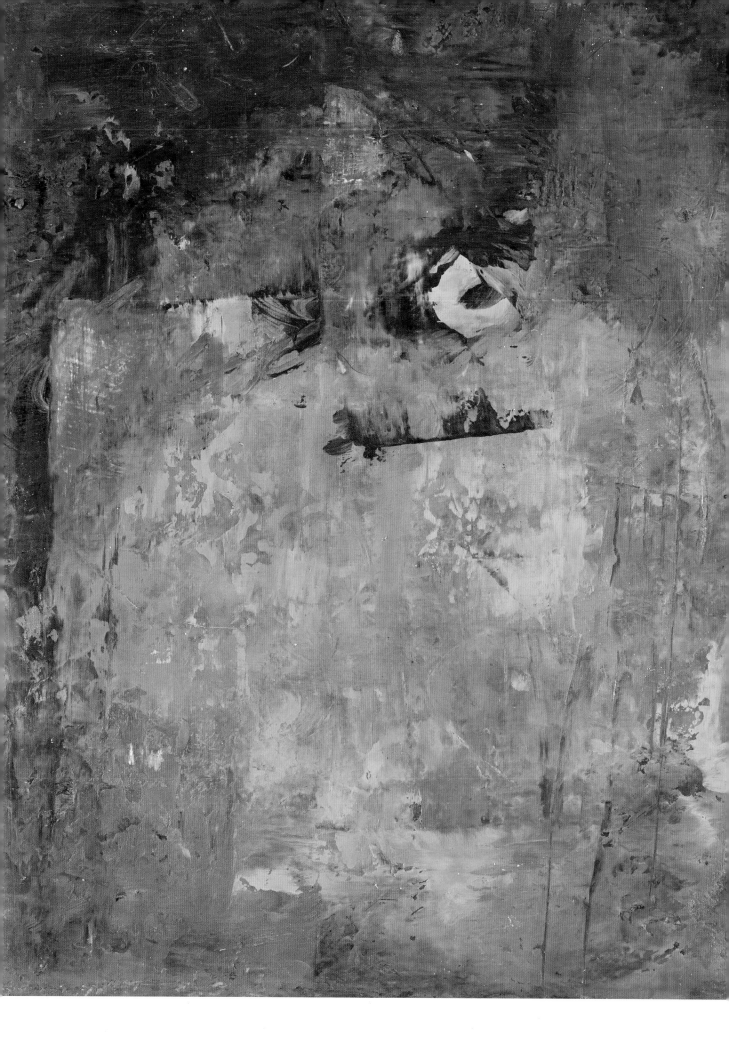

10 pushing the limits

When I was a child, I was a bookish, theatre-loving sort. I wasn't interested in science. My brother was the one who got the chemistry set. At long last, now I finally get to enjoy bold experiments and reckless mixing of ingredients. So far, there have been no explosions!

Like young children, artists are always trying to see what they can get away with. What substances can we add to our usual media? What happens if we break a particular rule? Sometimes the results of pushing limits teach us why the limit was there in the first place. But then there are the times when you make amazing discoveries with your willingness to try something new.

When I first started painting with oil and cold wax, it wouldn't have occurred to me to add collage to a piece. But after a while I began to hear faint rumblings about collage and oil and wax being combined with great success. So I had to try it. I came up with some ideas on my own, but soon found out that many other artists had come up with the same ideas. Sometimes there's just something in the air. Also, oil and cold wax artists are generous in sharing their discoveries.

In this chapter, we'll explore some limit-overcoming techniques, such as using cloth in oil and wax work and painting an oil-and-wax piece *alla prima*, or all at once.

◄ **BONFIRE NIGHT**
Oil, cold wax and marble dust on panel. 14" × 11" (36cm × 28cm)

the creative process

I used oil ground to prepare this piece. When the oil ground was thoroughly dry, I added Venetian plaster and attacked the plaster with combs and other implements of texture. I added several paint and cold wax layers and used the squeegee to smooth each layer, leaving the texture from the plaster showing. The last full layer was Raw Sienna. Through this layer, you can see some earlier layers of red, blue and Titan Buff. I used the bamboo skewer to incise in various areas.

I wanted to use a lightweight cotton muslin for fabric accents and wanted the muslin to be a focus of interest. I'd never rusted cloth before this piece but knew I could find out how to do it on the Internet. After looking at various sites, I felt I had a handle on what is a fairly easy process. I found a few rusty objects in the studio, but nevertheless repaired to the local second hand store for more rusty items.

After rusting the cloth, I tore off a couple of pieces from the areas with the most interesting markings. I collaged them into the top paint-and-cold wax layer. I had to press really hard to get them to lie down nicely. Several times I had to go back and repeat the process, but they did eventually dry and become one with the paint and wax. I then softened the appearance of the cloth areas with a little more Raw Sienna and cold wax.

At this point, the piece was crying out for contrast. I tried powdered graphite mixed with cold wax in the areas surrounding the cloth. I used a plastic comb to make marks in the wet graphite and wax. I liked the graphic quality of this and decided the piece was finished. When the piece was entirely dry, I added a clear layer of cold wax, let the wax dry and buffed the piece.

I didn't have an idea in mind when I began the piece. The title came to me as I looked at the finished painting. I relate the title to the experience of going through my mother's clothes a couple of months after she died. I thought this would be an difficult task, but it wasn't. Seeing her familiar clothes was bittersweet, but it did bring back many positive memories. Despite her having been very tall and slender, while I'm short and of average build, I found some clothes in her closet that I was able to wear. Wearing her clothes comforted me.

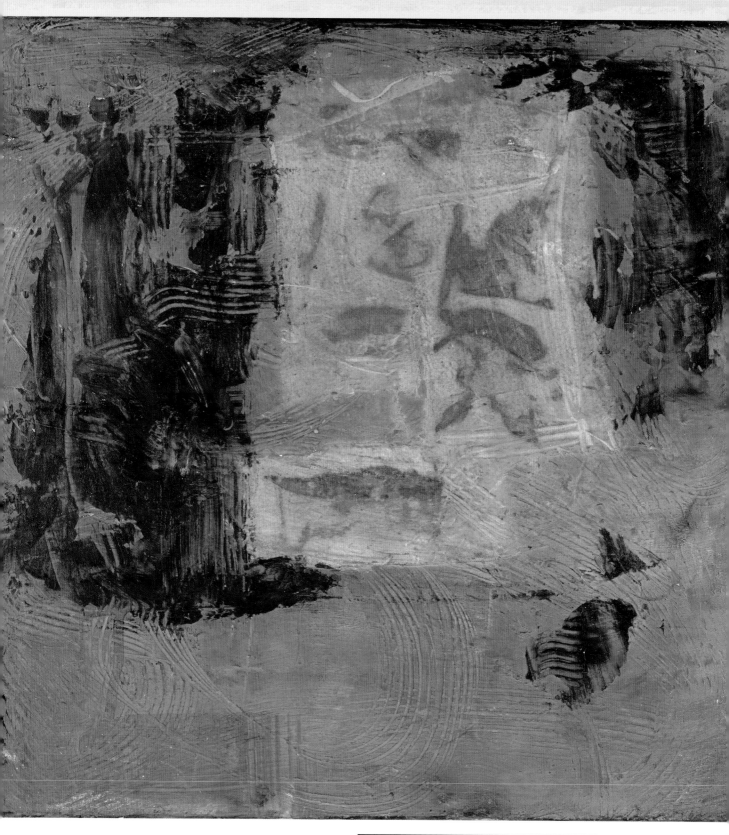

▲ MY MOTHER'S CLOTHES
Oil, cold wax, plaster, graphite powder and rusted cloth on panel.
12" × 12" (30cm × 30cm)

ADDING CLOTH

Follow the steps to learn how to use a piece of cloth to embellish your artwork.

Materials

artwork in progress

brayer

cold wax medium

lightweight cotton muslin

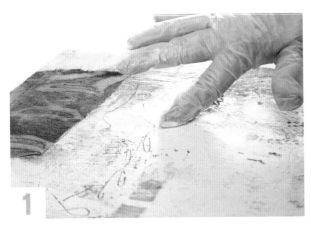

1 Cut or tear a piece of lightweight cotton muslin. Apply a coat of cold wax medium to the area where you want to put the cloth.

2 Press the cloth into the chosen area and use a brayer to burnish it in so that it lies flat. Apply a coat of cold wax medium over the cloth and burnish gently. Soften the edges of the cloth piece as desired. If you wish, you can add a little oil paint to the top cold wax medium layer.

how to rust cloth

Put on rubber kitchen gloves before you start. Find some small to medium size rusty metal objects. Lay them on a plastic or metal tray and spray them with a solution of 50/50 vinegar and water. (I lay the objects on an old cookie sheet.) Spray or soak your muslin with the vinegar solution. Then wrap the rusty objects in the muslin in a random way. Put heavy plastic over the bundle loosely enough to let some air through. Set it aside. My objects were super rusty so my cloth was nicely rusted in about twenty-four hours.

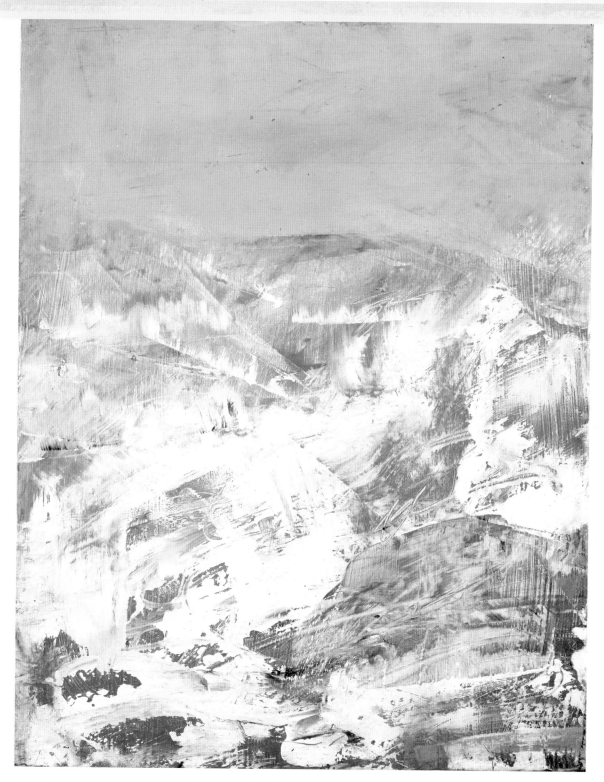

◊ ROCKS AND WATER
Oil and cold wax on panel.
14" × 11" (36cm × 29cm)

PAINTING ALL PRIMA

On a panel with a thinly applied gray layer, I used a palette knife to put down Titanium White mixed with cold wax. I then used a squeegee to move the white-and-wax layer around over the bottom two thirds of the piece. I suddenly saw rocks and water! The piece felt finished except that it needed more variation in color on the top part. I added some Titan Buff over the gray on this part and voilà!

Once in a while a piece comes together in just one painting session. It's fun to experiment with the alla prima or "all at once" technique. It's good practice in teaching yourself to stop before you overwork your painting.

judy wise

I have been fortunate to know Judy Wise for many years. She is a fearless creator and explorer when it comes to art making. I think she must ask herself, "What if…?" every single day as she continually makes new and wonderful work.

Materials inspire me. I love playing with various materials in the studio to see what they will do when I experiment with them. I'm very curious. I'll get a question about what might happen if I add say, mica or sand to my matrix. Will it sparkle and add texture or be buried under subsequent layers? A question like that burns a hole in me until I try it out. For this reason, I have lots of unfinished work in my studio, but these questions keep me moving forward. Next to curiosity, I'd say that nature inspires me. I try to capture not only the visual impressions but also the emotional states that occur when my eyes give me that information.

I grew up on a desert where clear horizons and mirages were always happening. My piece in this book is an image stored up from those many sightings. That glitter and haze on a far horizon. There are magic and awe in that for me, and I tried to convey these in this piece.

I usually just see what happens with a piece, rather than starting with a specific idea. The surprise of what emerges is everything to me. I think of my paintings as messages from the other side. I never know what they mean until I've painted them. They bring me information. After I've finished a painting, I have to sit with it to coax out the meaning. Some take longer than others to give up their secrets. This is something you can't force. Every image can be connected to a place you've been or something you've seen or experienced. I like that.

Sometimes I use other media with oil and cold wax, such as fabric and collage. I'm all about mixing media and experimenting. I love any tool that makes a mark. I'm a mark-making monkey!

I'm always lifted up following a teaching engagement, inspired to get back into my own studio and be busy. My creative fuel comes from connecting with others, from sharing, from feeling that I have something of value to give. I've always wanted to teach and connect as well as create, so teaching will always be something I want to do to contribute to others.

I find painting to be the most challenging, fulfilling, emotional and spiritually significant activity in my life. It always has been, from the time I drew my first face on the blackboard with my mother looking on (she showed me how). It is my magic, my manna, my gold. It has saved me from despair and made my life a walking dream! I'm passionate about art, not just painting but the sister arts of writing and teaching. I love the creative people I get to meet when I teach. I can't imagine a happier place to be.

about judy wise

Judy Wise is an Oregon artist, writer and teacher whose work has been published over several decades in books and periodicals and on greeting cards, textiles, educational materials and calendars. Her work spans the mixed-media spectrum, from journaling, watercolor and acrylic painting, encaustic and oil-and-cold wax painting, to stenciling and printmaking.

For the last five years, Judy has taught at mixed-media workshops around the world. She is the co-author of *Plaster Studio: Mixed-Media Techniques for Painting, Casting and Carving,* published by North Light Books. She has e-books available through her blog on cold wax, hot wax, mixed media journaling and plaster.

Judy knows that art saves lives and that everyone can be creative if they are adventurous. She is a passionate lover of all things artful and of helping others find joy in the process of self-expression.

judywise.com
judywise.blogspot.com

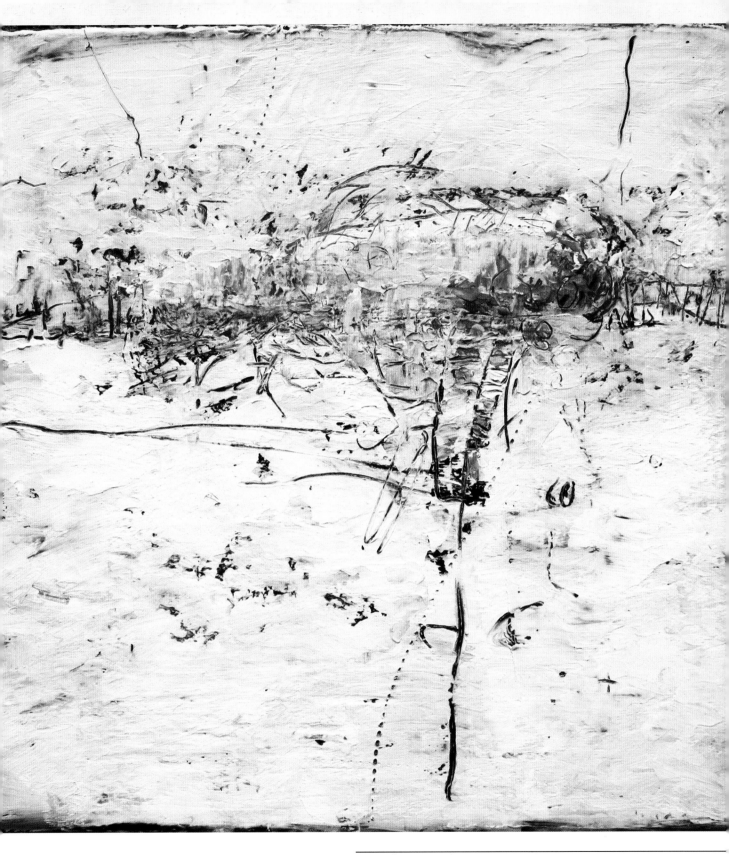

⬥ MIRAGE
Oil and cold wax on canvas. 10" × 10" (25cm × 25cm)

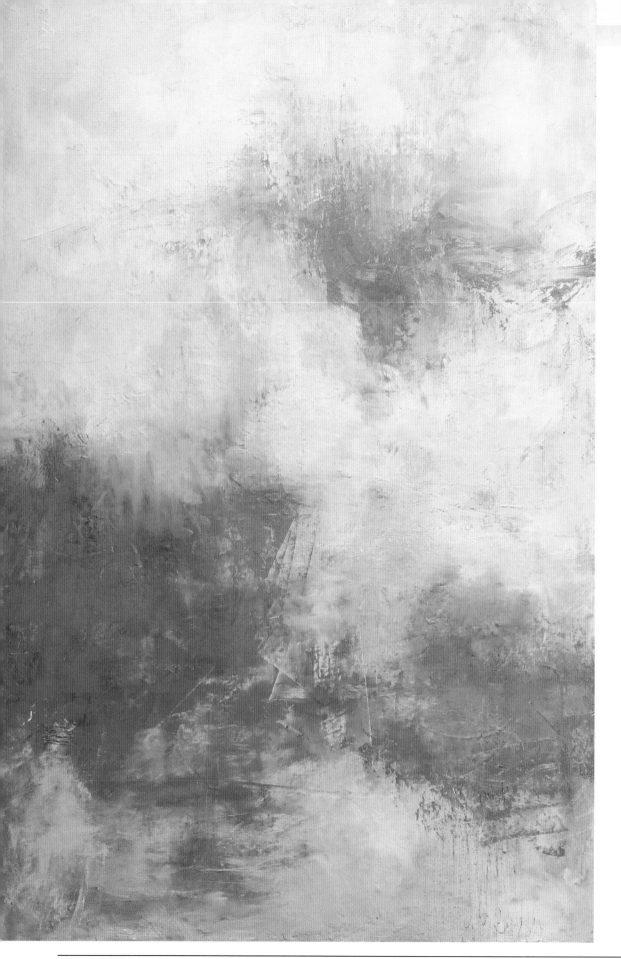

⬥ FORTUNATA
Oil, cold wax and oil pastel on canvas. 24" × 18" (61cm × 46cm)

complex simplicity

After I had chosen the phrase "complex simplicity" to describe my wabi-sabi work, I discovered that a lot of us oil-and-cold wax artists use the term to describe what we hope to achieve. Jim Scherbarth uses the term in this book. In a video on her website, Karen Darling quotes the sculptor Brancusi as saying that "Simplicity is complexity resolved."

Because of the variety of texture and layers in oil and cold wax work and the technique of letting previous layers and textures show through the surface, paintings done in this medium are naturally rich in complexity. In most cases, I find that it works well for us to create many marks, textures and shapes. Then we can take this complexity and edit it down until only what seems essential is left.

When I was younger and appeared frequently in local theater productions, a director told me that it is better to overplay a part than to underplay it. It's more effective to calm down an overblown interpretation of a role than to try to infuse energy into a flat one. This advice has stayed with me and seems to apply to the creation of oil-and-cold wax work as well.

As I have mentioned, no marks, layers or textures that you put down are wasted. Their energy will show through in the piece even when individual areas are covered over in subsequent layers. The simplest composition will ring with complexity due to the process of its creation.

I think this process mirrors life as well. We usually have to live through complex periods of change and emotion before we can begin to hone our art of living.

In this chapter, we'll cover unifying a piece so that disparate elements don't fight with each other but achieve a harmony of purpose. We'll also explore how to edit or simplify a piece when it is time to bring it to completion. Finally, we will look at the finishing touches that allow the piece to sing.

DETAIL

I painted this piece over an old oil painting on canvas. It started out with more yellow and blue as well as the orange it has now. I used oil pastels to do a lot of scribbling on the piece and used several texturing methods. Finally it was time to edit. I used Turquoise and Portland Cool Gray to cover much of the canvas, texturing as I went. Hints of the previous layers show throughout the piece. It took a while for the title to come to me. Finally the Italian word "fortunata" came into my brain. Not only was I feeling fortunate to get to spend my time painting, we had just taken our teenage grandson on a short trip to another city. He had a great time and was a delight to travel with. Fortunata indeed!

the creative process

I was inspired by my materials to create this complexly simple painting. I had a shipment of new paints from my favorite paint manufacturer and I couldn't wait to use them. I had received a selection of warm earth colors—my favorites! I was more organized than usual and even tested out each new color on a piece of paper before I started.

I used a palette knife on most of the piece with a little smoothing from my squeegee. This piece doesn't have as many layers as usual, as I felt that the piece resolved quickly into something I liked a lot.

I used an uneven landscape format and mostly just the colors I'd gotten in the mail. The piece did need some contrast, so I mixed Titanium White with a smidgen of Ultramarine Blue and cold wax to make an accent color. I added the blue-white areas with the palette knife and gently brought the paint downward with the tip of the knife. I used a whisk broom over the partially dry surface to add more texture and let all the colors I'd used have their say.

When I look at this painting, I feel myself to be on a boat on a smooth lake, getting closer to my home on the shore. It's a feeling of joyful expectation and simplicity.

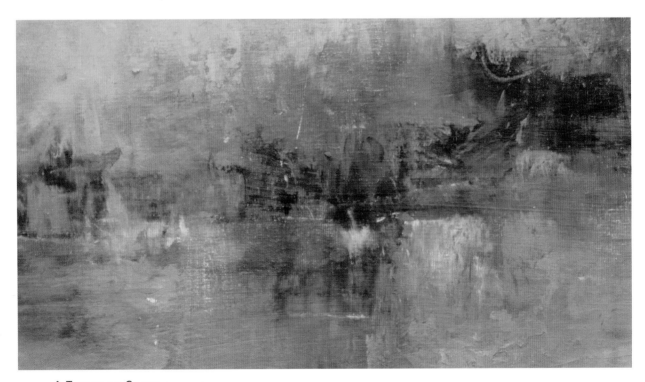

A TOUCH OF GRACE
A small amount of blue mixed with white added the right amount of complexity to this simple composition.

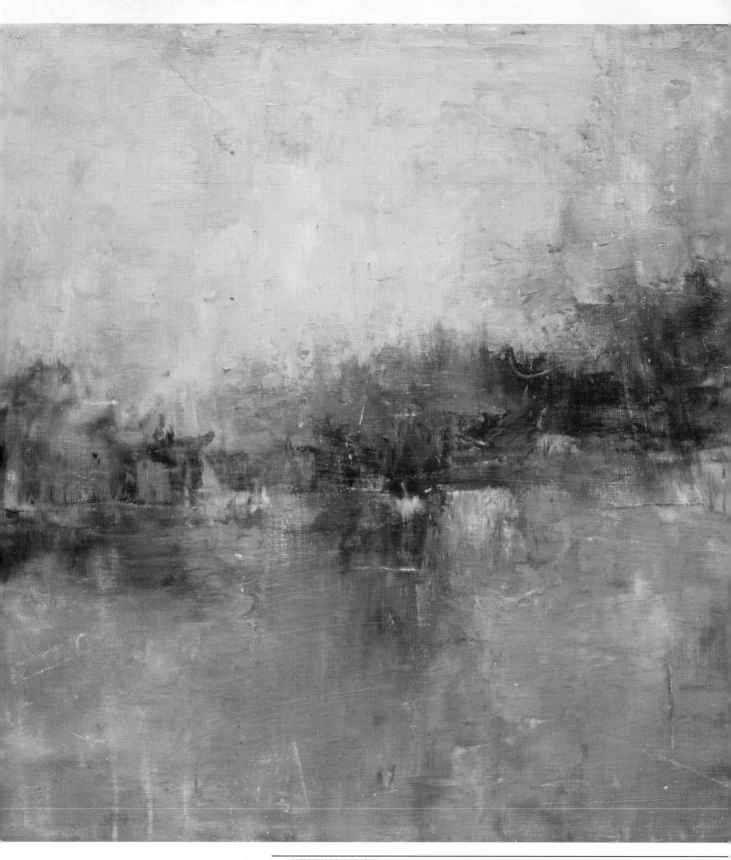

◄ ◢ HEADING HOME
Oil and cold wax and on panel. 18" × 18" (46cm × 46cm)

EDITING A PIECE

Let's simplify a piece. Follow the steps to experiment with extreme editing.

Materials

artwork in progress

cold wax medium

palette knife

squeegee

tube oil paints

various mark-making tools

1

Take an existing dry piece—one you don't like much or one you feel isn't finished. Use a neutral opaque tube oil color such as Titan Buff, Naples Yellow, Titanium White or Raw Sienna. Mix the color with cold wax medium and apply it to the support with a palette knife.

2

Leave areas of the original piece that you like or squeegee the new paint-and-wax layer back over these areas. Examine the piece to see if you prefer it with the new layer. If it is calmer, make sure that there are still areas of movement and interest.

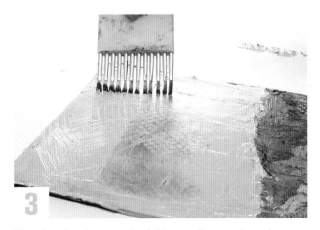

3

Examine the piece again. Add a small area of another color or texture.

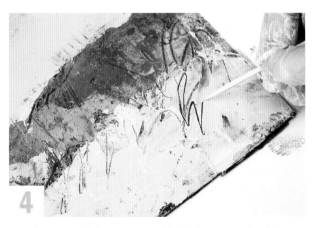

4

Continue to add in texture and/or incise as desired to make your piece's simplicity more complex.

UNIFYING A PIECE

One element of complex simplicity is unifying your piece. A piece can be as complex as you like, as long as there are unifying elements that tie the piece together. Follow the steps to learn methods for unifying a piece.

Materials

artwork in progress

cold wax medium

palette knife

pottery scraper

squeegee

tube oil paints

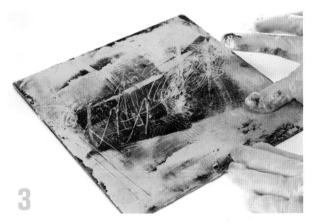

1

As you create your painting, consider adding a bit of the same color you used in one area to the color in another area. For example, if you have a piece in Burnt Sienna and Turquoise, add a bit of Burnt Sienna to one or two of the Turquoise areas and vice versa.

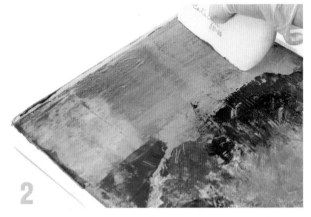

2

If you are using similar colors such as Ultramarine Blue and Pthalo Blue, you can add some of each color to the other when you put them on the support.

3

You can also do a layer of one color and let it dry. Then add another shade of that color and pull it back to show the first shade underneath. Use a pottery scraper to scrape back to larger areas of previous layers. Use it gently or vigorously, depending on how much you want to reveal. When the scraped-back areas look as you want them to, cover those areas with a thin coat of cold wax medium and let it dry.

editing your piece

Sometimes when you are editing a piece, you may notice that it seems to need more. Other times it may seem to need less. It can be challenging to decide whether to add or subtract in order to get the unity you want. Try taking a photo of the piece in process and printing out several copies. Use oil pastels to add to one image of the piece. Then use them to subtract from another image. You could also do this digitally if you have the skills. This should give you an idea as to what some of your options may be.

FINISHING EDGES

When I mask the edges during the creation of the piece, I like to use black or another dark paint to finish the edges, unless the piece is predominately white or another light shade, and then I use that color. Follow the steps to learn how to finish the edges of a piece.

Materials

acrylic paint or acrylic gesso

Ceracolor

cold wax medium

finished painting

masking tape

soft cloth

tube oil paints

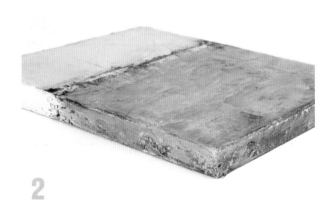

1

If you have masked your edges, paint them with acrylic paint after applying your primer over the wood edges. You could also paint them with Ceracolor over acrylic gesso or use oil paint over your primer of choice.

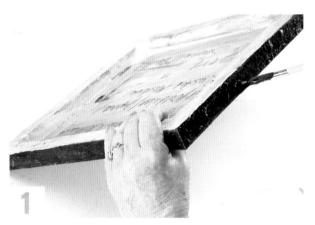

2

If you have continued to work on the edges as you worked on the piece, check to make sure they haven't picked up any color or texture you don't want. Check your piece for any stray debris that has gotten into the paint surface. (Cat hair is a particular offender.) Remove said debris carefully.

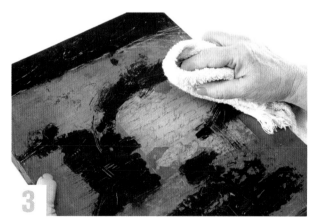

3

When your piece has been dry for several weeks, apply a thin coat of cold wax medium as a sealant. Let it dry and buff up your piece with a soft cloth for a slight sheen.

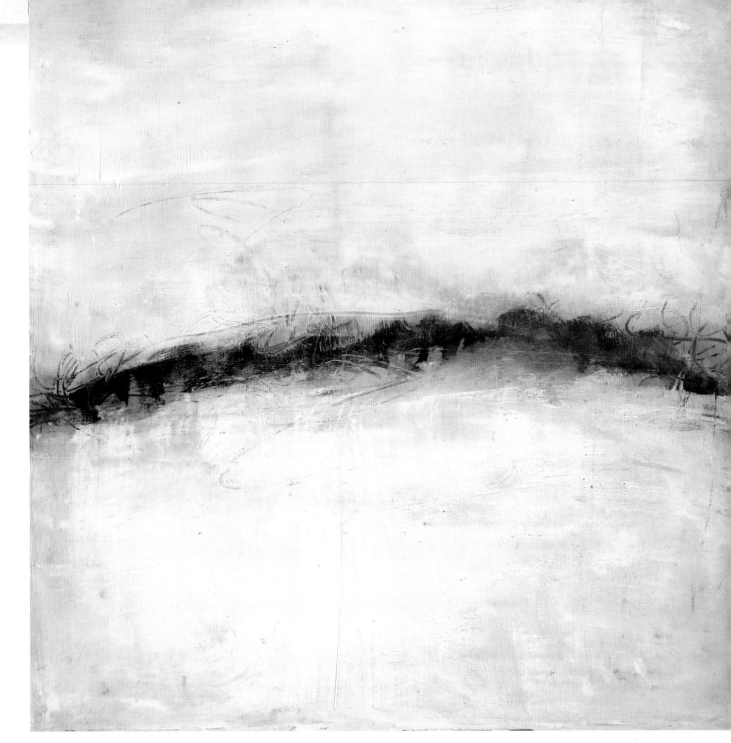

▲ EDGE OF THE WORLD
Oil, cold wax and acrylic on panel.
12" × 12" (28cm × 28cm)

CREATIVE PROCESS

This painting is an example of extreme editing. It also borders on rule-breaking but doesn't step over the line. I took an old acrylic piece and covered it with white and off-white oil paint and cold wax. I scraped back to reveal part of the acrylic and incised into the oil and wax areas, as well as some of the acrylic areas. I covered the acrylic areas that were revealed with clear cold wax. This works because you can put oil and cold wax over acrylic, but not vice-versa. So far, I've had good luck with using oil and cold wax over acrylic. A coat of gesso or other primer may be needed over an acrylic piece before it is covered in oil and cold wax to make the piece truly archival. (Whatever you do, refrain from painting acrylic over oil—the acrylic layer will peel off completely within just a few hours.)

kathleen menges

I've followed Kathleen Menges' work online for many years, marveling at her evocative landscapes. When I found out she is now working in oil and cold wax, I was thrilled. We share a strong affinity for the ways intuition and experimentation interact with this medium to allow us to produce from deep within our souls.

I paint to express the relationship between my creative process and my intuition. I work primarily in cold wax and encaustic, building multiple layers of textures. Then I scrape, make marks and dig to unveil hidden aspects. The results are works of Abstraction and Abstract Expressionism created to effect peace and calm to inspire and heal. I believe that once a painting is completed, it has a life of its own.

Inspiration is everywhere—nature, traveling or just a day out with my camera. I like to capture textures and colors that spark an idea. My inspiration is heightened by striving to be present, being playful and experimental.

I meditate and look for a calm place to begin. In this place of peace, I am able to be open to anything that comes. I sometimes dream of a painting or an idea for a painting, and I explore it. Most of the time, the finished painting has no resemblance to the original dream, but the energy of it is there. Mostly, I just let it happen. That is, I let intuition play its role. Even when I have an idea, sometimes the painting just wants to go in another direction. I find it is good to remember control is an illusion and surrendering to your process is where the real creativity is.

Cold wax with oil has so many possibilities. It can impart a lot of texture, transparency and the ability to scrape back and reveal what is underneath. You can add a lot of interest to the paint with powdered pigments and graphite powder. The truly great thing about this medium is that it makes the paint dry a lot faster, so the layering goes easier. The paint comes out with a matte finish, but I like that you can polish it in the end.

My favorite tools are dough scrapers made out of silicon, all different sizes of palette knives, dental and pottery tools. When thinning my paint, I use Galkyd oil medium by Gamblin for fast-drying enamel-like surfaces, and Galkyd Lite if I want less shine than the Galkyd provides. They both impart a transparent quality and shine. I enjoy applying a thin glaze to finish—it adds something special to the finishing of the painting.

I find that I feel spirit in the room with me when I paint; I am moved by it and the energy I receive comes through. My paintings often reflect what is happening in my life, so emotions play a large part in my work.

about kathleen menges

Kathleen Menges has always been deeply inspired by her natural surroundings. She was raised in Winnipeg, Manitoba, Lake of the Woods, and Ontario, Canada. It is this inspiration from the natural world along with her calm meditative energy that is infused into her work today. She paints works of Abstraction and Abstract Expressionism, created to effect peace and calm, to inspire and heal.

Kathleen has studied with Rebecca Crowell, Janice Mason Steeves and Elise Wagner, as well as at Emily Carr University in Vancouver, British Columbia, Canada. Her education ranges across oil painting, encaustics, cold wax, mixed media and sculpture. She brings all of her diverse background education into her current artworks.

She has had solo shows in and around Vancouver at The Reach Gallery Museum, The Pencil Studio, Silk Purse Gallery and Hycroft Women's University. Kathleen now resides in Abbotsford, British Columbia, where she has her studio. Her predominant focus is on cold wax and oil, encaustics and teaching.

kathleenmenges.com

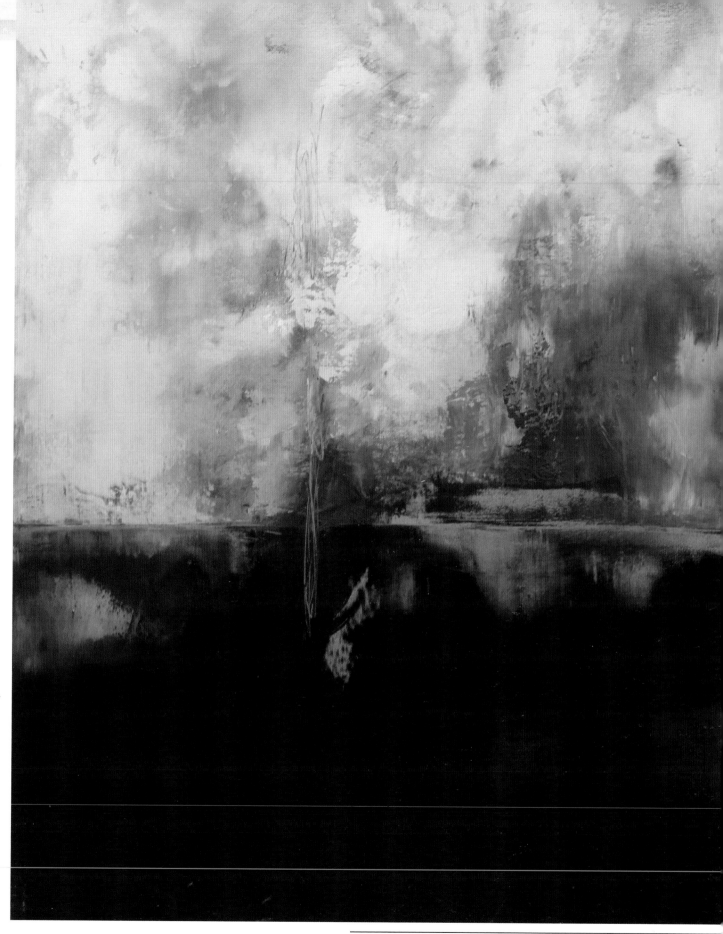

SMOKE AND ASH
Oil and cold wax on panel. 20" × 16" (50cm × 41cm)

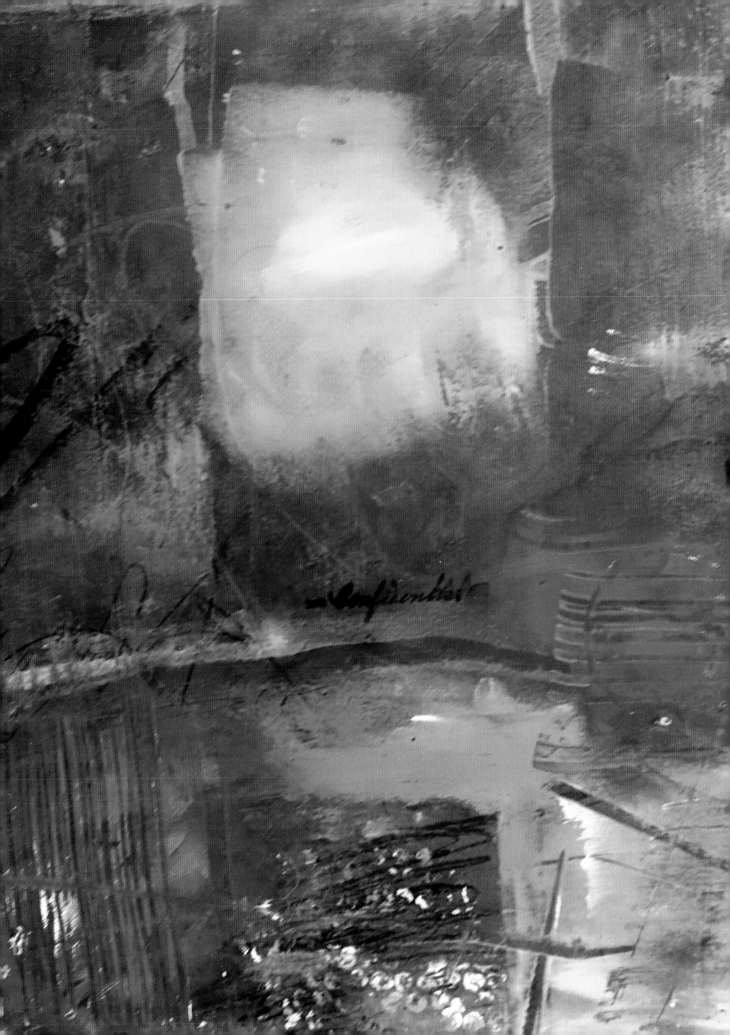

12 wax transforms paper

I can't tell you how excited I was when I found out that oil and cold wax could be used on special papers without any preparation layer! I had done a few pieces on paper by coating the paper with gesso first, but this didn't seem very interesting. Why do this when a panel is sturdier?

Two products have made it possible for oil and cold wax artists to enjoy the freedom of using paper that water-based media artists have long had. Arches makes an oil paper that looks and feels like other high-quality art papers, but it can also absorb the oil and cold wax with no bleed-through or degradation of the paper. Since you don't have to put down primer on this paper, you get to make use of its tooth.

Quite different but equally wonderful is TerraSkin stone paper. This paper is made from calcium carbonate and a small amount of non-toxic resin. No trees are harmed in the process! Working in oil and cold wax on this paper is a revelation. I was delighted with the way the oil-and-wax mixture glided along the smooth surface of the paper, and how well it was absorbed when left to dry. Fewer layers are necessary with this paper to achieve a fully completed piece, and you can get great transparent effects.

You're about to discover the fun of painting with these unusual papers.

CREATIVE PROCESS

This piece has some very complex areas and some simpler, more restful areas. I've repeated the square-ish shapes and the round shapes but varied the size of the shapes. The red circles and gold square lead the eye around the piece. The black script in the background and the white dots in the foreground provide contrast to the brightly colored areas. I used a vintage-style rubber stamp in the center. I call the piece *Case Study* because it reminds me of a family constellation of some kind. That's the counselor in me coming out!

◄ CASE STUDY
Oil, cold wax and ink on Arches oil paper.
14" × 11" (36cm × 28cm)

the creative process

I named this painting as I did because "zest" is what I felt while making it. There are just a few layers of paint and wax on the piece, but lots of textural interest. I first put down a layer of Indian Yellow, a yummy transparent color. When that dried, which was fairly quickly, I added a layer of Viridian, a transparent blue-green. While this layer was wet, I used my squeegee to pull back to the yellow to reveal a square shape. I rubbed the yellow paint back in the center with a paper towel. I let the yellow show through a little in a few other areas.

I incised text-like doodles and other marks into the green layer. When this layer was dry, I added Red Iron Oxide and wax over the top area of the painting. I got out my old meat thermometer to incise circles in the lower part of the red area, revealing the green and yellow layers. I used my rubber basting brush to add more overall texture.

Incising and scraping back add a look of complexity to just a few layers of paint. In *Zest*, you can see how the paint and wax mixture glided smoothly along the paper, leaving some of the original paper surface showing. When working with stone paper, keep your layers quite thin so that the paper doesn't buckle when you frame it or mount it on a cradled panel.

All this was done in several hours. The process was both freeing and hassle-free. How often does that happen? When I look at this painting, I feel happy. It seems to echo some of the joy that painters such as Matisse brought to their work.

in the frame

If you paint on paper, you'll be wondering how to present your work. Karen Darling, this chapter's guest artist, frames her oil-and-cold wax pieces in a variety of ways, including occasionally framing large works on paper in a frame without glass. The work is mounted on a backing board with extra coats of wax used over the whole piece (including the white border) for added protection. Then it is framed. Another option is mounting the paper to a cradled board before painting, with the painted area going right to the edge.

Most often however, Karen frames her works on paper under glass, matting them to keep the oil-and-wax surface from coming in contact with the glass. She also finds that float framing under glass looks great when you want the paint edge and/or the paper edge to show.

► **ZEST**
Oil and cold wax on TerraSkin stone paper. 14" × 11" (36cm × 28

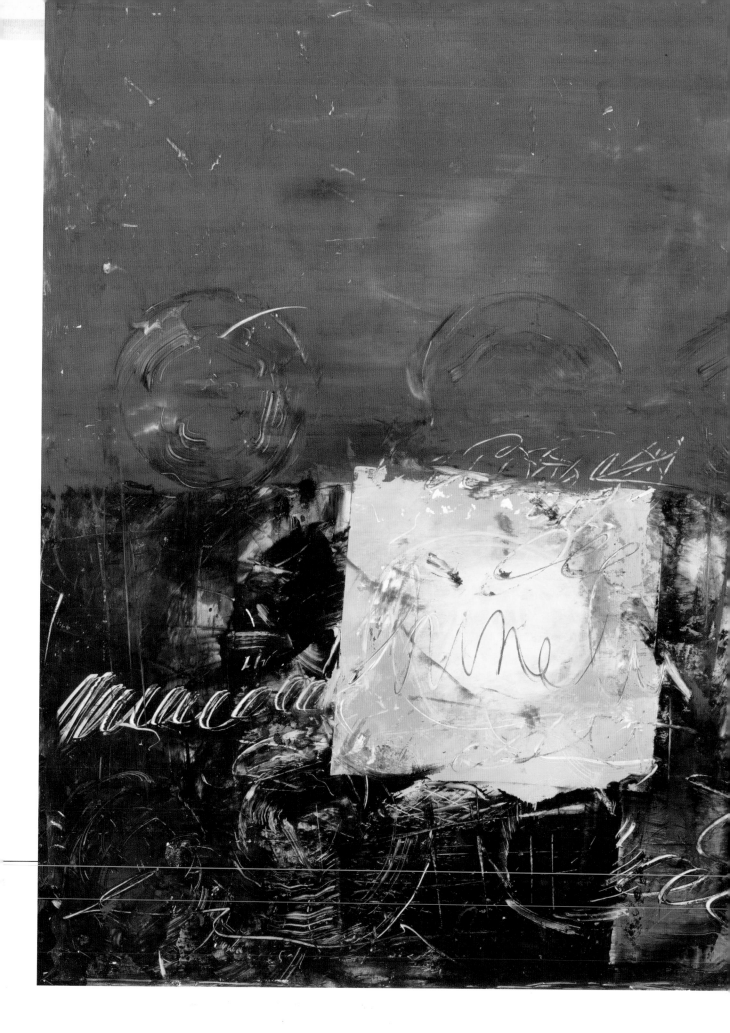

PAINTING ON ARCHES OIL PAPER

Arches oil paper is a toothy paper that loves texture. Follow the steps to practice techniques for painting on this paper with oil and cold wax.

Materials

brayer

cold wax medium

palette knife

masking tape

sheet of Arches oil paper

squeegee

stencils and stamps

tube oil paints

various mark-making tools

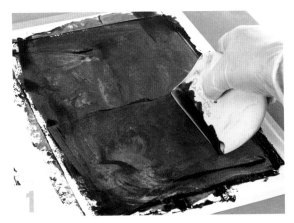

1 Mask the edges of a piece of the paper. Start right in applying a thin layer of oil and cold wax with a palette knife. Smooth out the color with a squeegee. A brayer also works well, as it covers a lot of area and makes use of the tooth of the paper. Add texture and incising as desired.

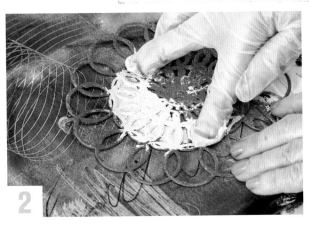

2 Experiment with stenciling.

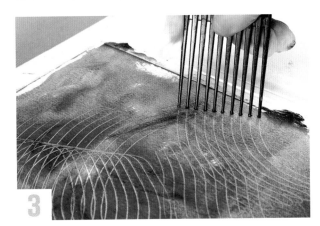

3 Add marks with the mark-making tools of your choice while the paint is still wet. Add other layers as desired.

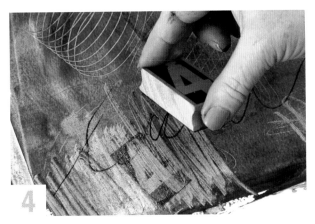

4 Add one or two subtle areas of rubber stamping over a dry paint layer. Mute the stamp marks if desired.

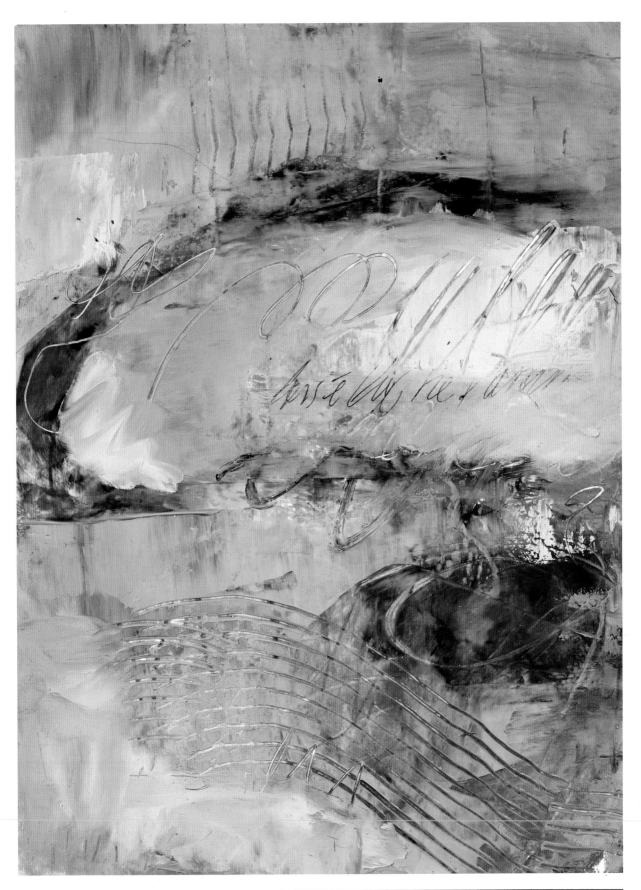

◊ OHIO FALL
Oil, cold wax and collage on Arches oil paper. 9" ×12" (23cm × 30cm)

karen darling

Karen Darling is a master at bold, graphic and emotive work in oil and cold wax on paper. She works on oil paper and stone paper, creating powerful non-representational paintings. In this book, she shares one of her diptych pieces. Both paintings can stand alone or work together to form an even more meaningful and stunning visual statement.

Inspiration for me comes from so many places. It could be textiles or wallpaper, landscape views around me, typography, photography, interior design elements, fashion, cityscapes, weather, new artists' materials and even music! I also make a habit of drawing and painting from the live model on a weekly basis. Even though I may approach the work from a more realistic standpoint, I am always searching for the abstract shapes. I find the fluid, gestural mark-making that comes from figure drawing tends to inform my abstract work and vice versa.

I am definitely not an artist who works out ideas completely beforehand by doing sketches first etc. I may have a general value composition in mind, a feeling of where I want the darks and lights, but beyond that I prefer to just start and then respond to what is happening as it happens. One of my favorite quotes is from artist Richard Diebenkorn. He said, "I can't paint what I want, only what I would have wanted had I thought of it beforehand." Even though it can be a somewhat frustrating way to work at times, I find there is more room for happy accidents to occur this way.

I like to work in very thin layers of oil and cold wax. I find it allows for the memory and history of previous layers to show through and also creates the ambiguity that I am after. One tool that I find indispensable is a silicone dough scraper. The flexible yet firm edge allows me to manipulate the oil and wax across the surface. I like to use tools that force me to keep my painting and mark-making loose. I also enjoy using charcoal and oil sticks to introduce drawing or calligraphic elements into the paintings.

I have worked on paper almost exclusively for the last couple of years, which enables me to work larger and more spontaneously than on rigid supports. There have been a few advancements in paper for the artist recently that I find very exciting. There are papers available now that allow for oil paints to be used without having to gesso first. I also like working with stone paper, which is made from actual stone powder rather than paper pulp and has a wonderful smoothness unlike any other paper. One of the other advantages to working on paper is the relative ease of shipping. I have shipped artwork all over the world safely and easily at far less a cost than rigid supports. One thing I have found is that when I use Arches oil paper as the support, I tend to work with many, many layers. If I am using stone paper, I tend to use inks or charcoal with only a few layers of oil and cold wax over the top. The stone paper can buckle just a bit if too much wax is used.

I'm not sure if my paintings express what is going on inside me as much as they express what is going on around me. I have definitely noticed a seasonal difference in my work. In Canada, we have four distinct seasons and each one tends to inspire a slightly different color palette, intensity, value scale or atmosphere.

about karen darling

Karen Darling graduated from the Illustration program at Sheridan College's faculty of Animation, Arts and Design in Ontario, Canada. After a few years as a freelance illustrator in the advertising community, she turned her focus to the restaurant industry and opened a successful restaurant that is still going strong today. She has since returned to her art career and has been working as a painter and sculptor for the last several years. Karen has won numerous awards and is represented in private collections across North America and the UK. She was asked to provide all the artwork to be used in the motion picture *Dream House*, released Fall 2011.

"Exploring new ways of expressing myself led to a much looser and more abstract feeling in my figurative work, and in turn, led to completely nonobjective abstract paintings. Recently the introduction of wax into my painting process has allowed for multiple translucent layers that add depth and ambiguity. Scraping back through these layers reveals even more than anticipated. It is this constant push/pull between happy accident and purposefulness that captivates me, and hopefully the viewer."

karendarling.ca

◊ DEFIANCE/FLEETING THOUGHTS
Oil, cold wax and charcoal on panel.
39" × 51" (99cm × 130cm) / 36" × 51" (91cm × 130cm)

Index.

ABOUT THE AUTHOR

Visual art was Serena Barton's first love as a child. She moved on to acting in local plays and later became a licensed professional counselor. Serena rediscovered her desire to make art following her first trip to Italy. She taught herself to paint and create mixed-media work in mid life, proving it's never too late to create!

Serena holds creativity and art workshops, as well as group and individual art coaching at her studio and at national art retreats. She exhibits and sells her work through galleries and shops, as well as online. Serena has published *Wabi-Sabi Art Workshop* (North Light, 2013) and *A Joyful Frenzy*, a book of her artwork with text on the stories and processes behind the work. Her magazine articles have appeared in issues of *Cloth Paper Scissors* magazine and *Studios* magazines and in *Cloth Paper Scissors* e-Books.

Serena's greatest joy is to provide an atmosphere in which you can discover or rekindle your own creative abilities. She lives in Portland, OR with her partner, near her children and grandchild. She loves hanging out with family and friends and is an avid reader.

Visit her website at serenabarton.com.

Visit Serena's website, www.serenabarton.com, and her blog, serenabartonsblog.blogspot.com.

METRIC CONVERSION CHART

CONVERT	TO	MULTIPLY BY
Inches	Centimeters	2.54
Centimeters	Inches	0.4
Feet	Centimeters	30.5
Centimeters	Feet	0.03
Yards	Meters	0.9
Meters	Yards	1.1

DEDICATION

To Dot. I couldn't do any of this without you. xo

ACKNOWLEDGMENTS

A huge thank-you to the wonderful North Light Team—editor Christina Richards; book designer Brianna Scharstein; photographer Christine Polomsky; and my former editor and encourager Kristin Conlin.

A full-hearted thanks also goes out to my students, who continue to teach me and who give me such joy.

a content + ecommerce company

Other fine North Light Books are available from your favorite bookstore, art supply store or online supplier. Visit our website at fwcommunity.com.

19 18 17 16 15 5 4 3 2 1

DISTRIBUTED IN CANADA BY FRASER DIRECT
100 Armstrong Avenue
Georgetown, ON, Canada L7G 5S4
Tel: (905) 877-4411

DISTRIBUTED IN THE U.K. AND EUROPE
BY F&W MEDIA INTERNATIONAL LTD
Brunel House, Forde Close, Newton Abbot, TQ12 4PU, UK
Tel: (+44) 1626 323200, Fax: (+44) 1626 323319
Email: enquiries@fwmedia.com

DISTRIBUTED IN AUSTRALIA BY CAPRICORN LINK
P.O. Box 704, S. Windsor NSW, 2756 Australia
Tel: (02) 4560-1600; Fax: (02) 4577 5288
Email: books@capricornlink.com.au

ISBN 13: 9781440340499

Edited by Christina Richards
Designed by Brianna Scharstein
Production coordinated by Jennifer Bass

Ideas. Instruction. Inspiration.

Receive FREE downloadable bonus materials when you sign up for our free newsletter at createmixedmedia.com.

wabi-sabi art style
HOT WAX, COLD WAX & PLASTER

NORTH LIGHT DVD | an artistsnetwork.tv production

wabi-sabi
ART WORKSHOP

MIXED MEDIA TECHNIQUES
for EMBRACING IMPERFECTION and
CELEBRATING HAPPY ACCIDENTS

serena BARTON

COLLABORATE! 8 TIPS FOR MAKING ART WITH FRIENDS p. 32

5 BOOK SCULPTURES THAT DAZZLE p. 82

cloth·paper
scissors® COLLAGE ARTISTIC
 MIXED MEDIA DISCOVERY

tell your STORY

make a
mixed-media
SELF-PORTRAIT
p. 42

Find the latest issues of *Cloth Paper Scissors* on newsstands, or visit artistsnetwork.com.

These and other fine North Light products are available at your favorite art & craft retailer, bookstore or online supplier. Visit our websites at artistsnetwork.com and artistsnetwork.tv.

Follow North Light Books for the latest news, free wallpapers, free demos and chances to win FREE BOOKS!

Visit artistsnetwork.com and get Jen's North Light Picks!

Jen's PICKS

Get free step-by-step demonstrations along with reviews of the latest books, videos and downloads from Jennifer Lepore, Senior Editor and Online Education Manager at North Light Books.

Get involved

Learn from the experts. Join the conversation on

WetCanvas